INSPIRED BY LIGHT

a personal view

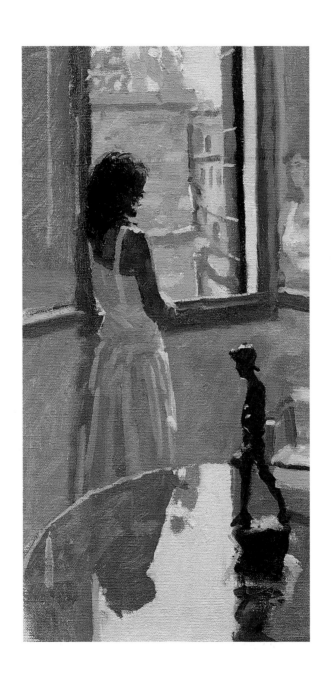

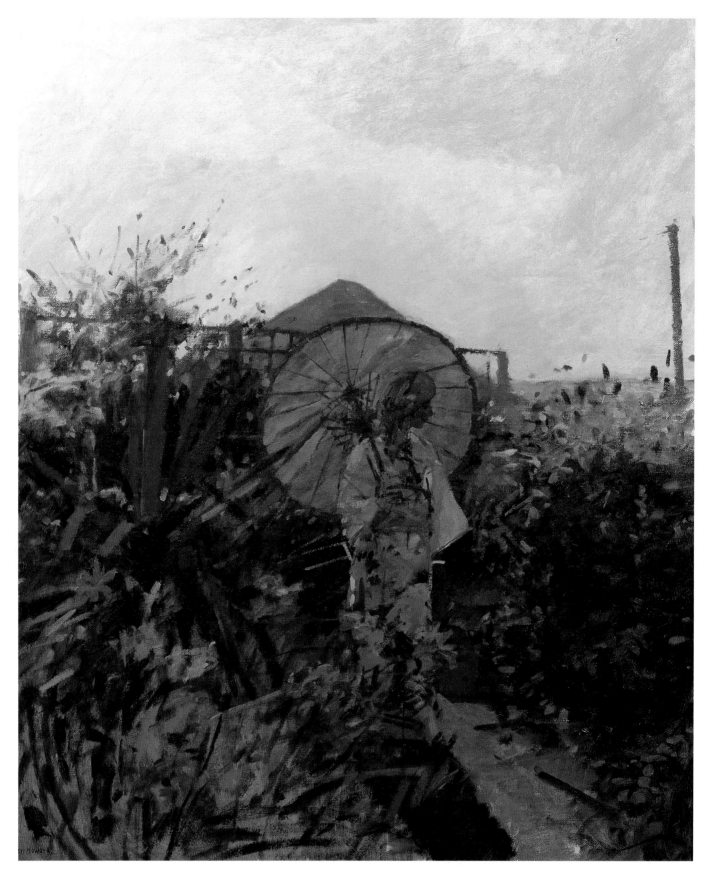

THE RED PARASOL (c1990)
Oil on canvas, 48 x 40in (122 x 101.5cm)

*Painted in my garden in Mousehole, this is an extension of my
studio kimono series, but here the light effect is heightened as a
result of the outdoor setting. I would love to have the courage of the
Newlyn painters and paint my models in outdoor settings more.*

KEN HOWARD

a personal view

INSPIRED BY LIGHT

KEN HOWARD
WITH SALLY BULGIN

David & Charles

ACKNOWLEDGEMENTS

I would like to thank all my long-suffering models, particularly
my friend Dora Bertolutti, all those collectors who have been so
co-operative in allowing their works to be photographed for this
book, and Roy Fox and Miki Slingsby for their highly professional
photography. My grateful thanks to Sally Bulgin for her patience and
our long hours of taped conversation which made the book possible.
Finally, my thanks to David Wolfers of the New Grafton Gallery and
Manya Igel and Bernard Prydel of Manya Igel Fine Art for their
continued belief in me and support over many years.

Although every effort has been made to provide accurate
measurements for the paintings illustrated, it has been
necessary, in a few cases, to resort to approximation.

A DAVID & CHARLES BOOK
First published in the UK in 1998
Copyright © Ken Howard, Sally Bulgin, David & Charles 1998

A catalogue record for this book is available from the British Library.

ISBN 0 7153 0841 6

DESIGNED BY THE BRIDGEWATER BOOK COMPANY

and printed in Singapore by C.S. Graphics Pte Ltd.
for David & Charles
Brunel House Newton Abbot Devon

CONTENTS

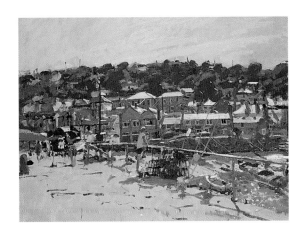

INTRODUCTION

Ken Howard: a Personal View means exactly that: everything in this book represents my current thinking. Tomorrow my thoughts and ideas may be different because I am continually looking, searching and, I hope, developing as a painter. Nothing I say can therefore be regarded as set in stone, partly because I believe that each day the painter must see the subject and approach his or her materials as if for the first time; each day should be a new journey of discovery.

In which case, you might ask, what was the point of writing this book? My hope is that you will draw some inspiration from it, for inspiration is, I believe, the most important part of any teaching. Of my own tutors, those I remember best are the ones whose tutorials left me wanting to pick up a brush and paint immediately. They inspired me, and I hope that you will find this book just as illuminating. After looking at the paintings illustrated here, perhaps you will feel that your eyes have been opened to aspects of the world you hadn't noticed before.

My personal view about painting is very straightforward. For me it is about revelation, communication and celebration, revelation being the most important. Artists reveal the world in their terms to other people, they impose their vision on the world for others to see. As an illustration of this, during my visit to a Whistler exhibition at the Tate a few years ago I began to see my surroundings through Whistler's eyes: visitors appeared to be wearing Whistlerian colours, standing in Whistlerian poses, forming Whistlerian compositions. His paintings impacted on me to such a degree that his vision of the world affected my impression of my immediate environment. I had a similar experience at an exhibition of David Hockney's work at the Whitechapel.

But of course painting is first of all about communication via the process of drawing and painting. Initially the painter must reveal the world to himself and then communicate this understanding to others. As in all art forms – including music, theatre, etc – painting is about an interaction between artist and audience. And if there is none there is little point in painting – certainly it should not be approached simply as a therapeutic process.

Celebration is perhaps the most questionable of my three fundamental principles about painting, because of course art can be about the darker sides of life just as much as its joyful aspects. For me, however, art must raise my spirits as well as impact on my perception. I want art to celebrate the beauty of nature, the human form and the human spirit. When I look at a painting, listen to a piece of music or read literature, I like to feel elevated beyond mundane reality and transported to a higher place. I know the ups and downs of reality; I have lost loved ones, suffered illness and known disappointment, but a painting by Vélasquez or a piece of music by Mozart offers me uniquely rewarding experiences that enrich my life.

Ultimately, the process of painting is all about practice. Some years ago when painting in the street in Verona, I was asked if I could teach an onlooker how to paint 'like you, teach me something'. My reply to such a question is that you need to paint for thirty years and if you have something to say you will say it. You can look at great paintings, read books to learn how to do it, study with good teachers, but without practice you will achieve nothing. Good teaching will provide you with the tools you need to express yourself by showing you how to draw, use colour and tone, and compose pictures, but you will only discover the artist in you by practising these skills.

Good painting has a magical quality, which is impossible to write about or imitate; it is unique to the artist and so for this reason it is important to be true to yourself. Fashion, or innovation for its own sake – typical of contemporary art – is quite pointless; nevertheless innovation is the buzzword today, and excellence and striving for perfection seem to have gone by the board. In the past, innovation was the province of the genius: Titian, Rembrandt, Vélasquez, Goya and Cézanne were all true innovators who were not just different – they contributed

ARTIST'S STUDIO, TITE STREET (c1983)
Oil on canvas, 48 x 40in (122 x 101.5cm)

As well as painting my own studio I love to paint those of other artists. This one is Julien Barrow's, an old friend; his wonderful north-facing window makes it a classic portrait-painters' studio as the direct light never penetrates the studio space, making it possible to work for many hours without the image changing.

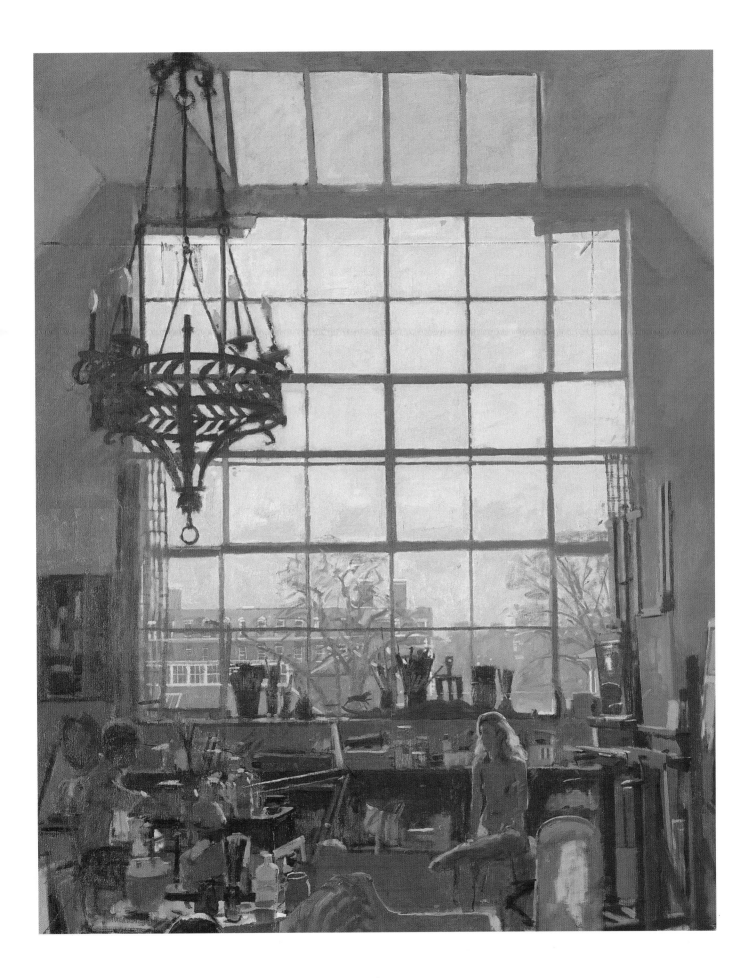

I

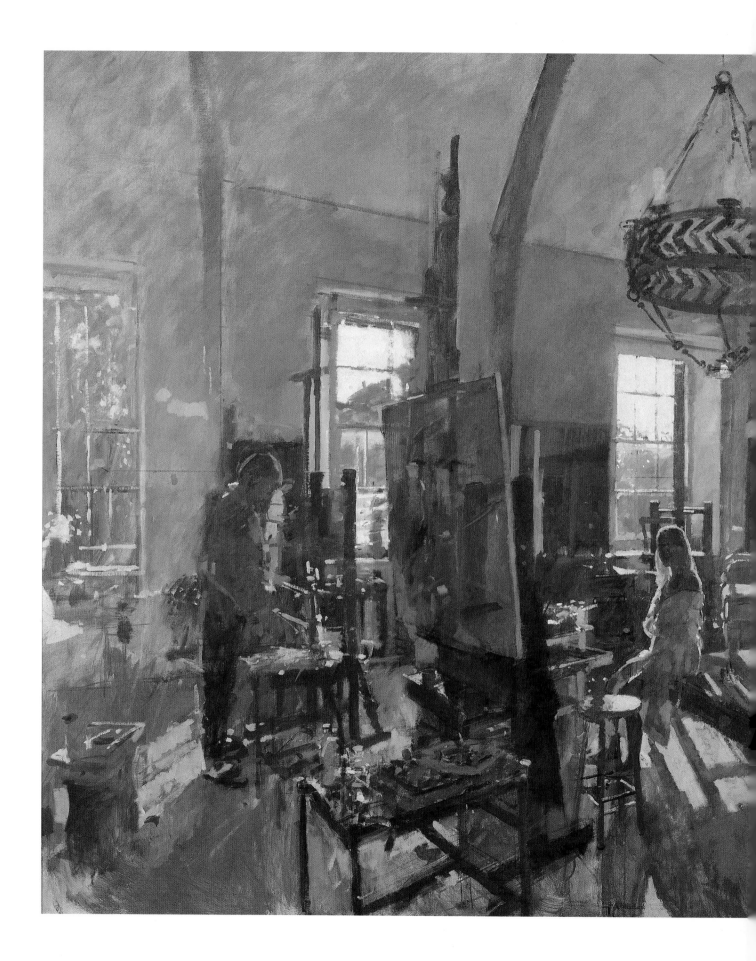

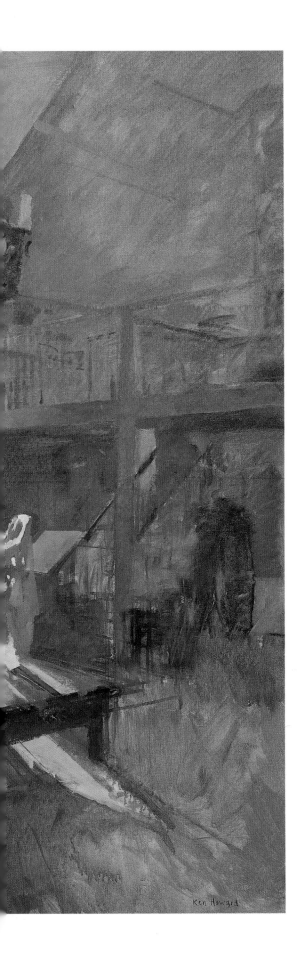

to the sum knowledge of visual perception. Few artists are as gifted, but this doesn't mean that the practice of painting has lost its meaning.

Drawing and painting are part of being human for me. I believe that if everybody were taught the fundamentals of drawing and painting in the same way that they are taught grammar and writing, and as long as they were willing to practise, then everyone would be able to express themselves visually. They might not become a Rembrandt or a Goya, but they would become richer human beings as a result.

In the following pages I talk about my approach to the processes of drawing and painting. I have included sections on drawing and watercolour, even though the book is mainly about oil painting, because I have always believed that drawing is the basis of painting (and indeed of many of the other visual arts). For me, watercolour is an extension of drawing and often a stepping stone to an oil painting. Indeed, painting in watercolour or oils is all about drawing with paint and I believe that there is no great difference in approach to the two media. Watercolour mixed with gouache and Chinese white has the same range of possibilities as oils. Both media can be used transparently, semi-transparently and opaquely. Of course, oil paint allows you to build texture and impasto, but there are more similarities than differences between the two.

I hope you will enjoy your journey through this book. If, after reading it, you have the desire to pick up a brush and make a painting, I will have succeeded in my purpose.

ARTIST'S STUDIO, CORNWALL (1996)
Oil on canvas, 60 x 72in (152.5 x 183cm)

I love to go into the studio in the morning and see a large painting gradually taking shape. Like Constable, I don't feel I am really painting unless there is a six-foot canvas on the easel; this one was on my easel in my studio in Cornwall for an entire summer.

DRAWING: A WAY OF SEEING

rawing is the basic grammar of painting. It is a language that can be learned by everybody, just as everybody is capable of learning how to make words and sentences from the letters of the alphabet. There is a logic to it: you start with a mark, which leads to a line, then a shape; the addition of tone gives the shape an impression of three-dimensionality, and the addition of texture gives a specific quality to the shape. It is a teachable and crucial skill.

It is also a tool that can help the artist to understand a subject. Through a drawing you reveal things about the world to other people – as Degas said, drawing is not about what one sees, it is about what one makes others see. But the most important reason for drawing is that it forces you to analyse the subject for yourself. You might be inspired by a particular subject, but until you start to draw it you cannot hope to understand it fully, and I have never met an accomplished painter who cannot draw well.

This is why it can be so dangerous for inexperienced artists to draw from photographs because all this encourages you to do is to copy the two-dimensional shapes of dark and light, or colours in a subject. By contrast, drawing from life is more visually analytical. It also teaches you how you use an abstract process – combinations of lines, shapes and tones – to describe three-dimensional objects on a flat surface. It is not simply about copying what is in front of you. For example, although we know that there

DRAWINGS AFTER VÉLASQUEZ (1953)
Pen-and-ink sketchbook drawings, 8 x 6¹/₂in (20.5 x 16.5cm)

I love the way Vélasquez represented the head as a basic shape, and used simple masses of tone to describe three-dimensional form.

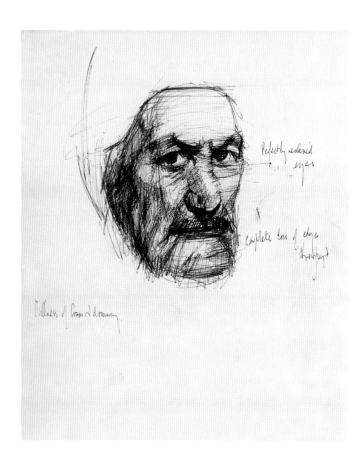

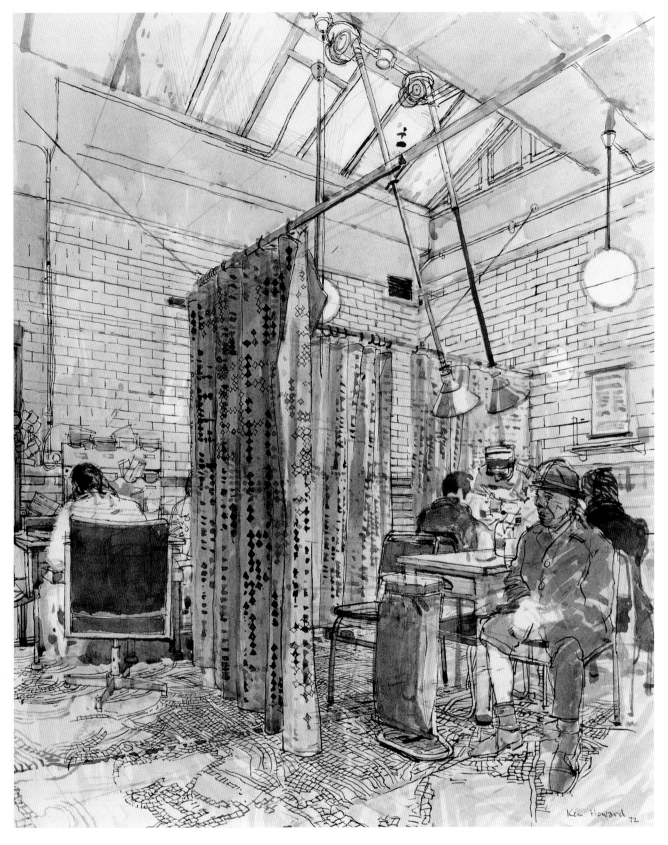

CHARING CROSS HOSPITAL (1972)
Pen and wash, 11 x 15in (28.5 x 38.5cm)

On-the-spot drawing which I had to work on quickly because people were moving about. In such circumstances it is a question of getting down the basic shapes in broad washes first, before overlaying with the pen to establish more detailed features.

are no lines running around forms in nature, we can see in Henry Moore's wartime underground drawings how the sculptor used contour lines to explain the three-dimensional form of his subject. As painters we do a similar thing, although perhaps not quite so obviously as a sculptor might.

THE ADVANTAGES OF PEN-AND-INK DRAWING

When I taught drawing at Harrow School of Art (from 1959 to 1973) I asked students to draw with a pen because, although you can indicate tone with a pencil, you cannot describe the range of tonal values as well as you can with pen and wash. Also, you get a more incisive line by using a pen.

One of the other great advantages of drawing with pen and ink is that you cannot rub it out. This means that when you make a mistake, and you are forced to make another statement over the top to correct it, you will see the two statements together and be able to refine your drawing gradually until you get it 'right'. Of course, you can use white gouache to make corrections, but I would advise against this until the drawing is well under way since one of the points of using pen and ink is that your early marks are still visible in the final drawing. This is one of the reasons I love working in this medium.

As a student I drew with a pen a great deal and relied heavily on 'think lines'. These helped me to work out the relationships between certain features in a subject – for example, the relationship in a figure drawing between the breasts and the navel. They are the evidence of a probing eye, every unsure decision, every change of mind, and I still use them today. Their usefulness should not be underestimated, they are part of the creative process of explaining to yourself what you are seeing, which is the very essence of drawing for me.

MEASURING TECHNIQUES

Although many people question the legitimacy of measuring techniques, for me the end justifies the means. And it is just as easy to make a poor drawing without mechanical aids as it is to make a wonderful drawing *with* their help.

Dürer is a classic example of a master draughtsman who used a drawing frame with an elaborate eyepiece which he could move back and forth until he could see through the glass as much or as little of his subject as he wanted to draw or paint. He then traced an outline on to the glass,

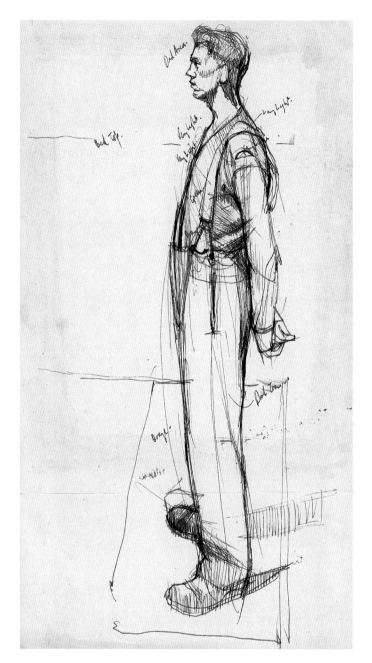

PORTRAIT OF A MARINE (c1954)
Pen-and-ink sketchbook drawing, 13 x 6in (33 x 15cm)

When I served as a Marine, I nevertheless drew and painted every day by making studies of my colleagues and by life drawing in the evenings. You can see in this drawing how I used 'think lines' to help me establish the correct relationship between the feet and the upper part of the body. I also made written notes about tone and colour.

Right: These pen-and-ink sketchbook drawings are examples of working across the form with the pen, exploring the three-dimensional form of the head.

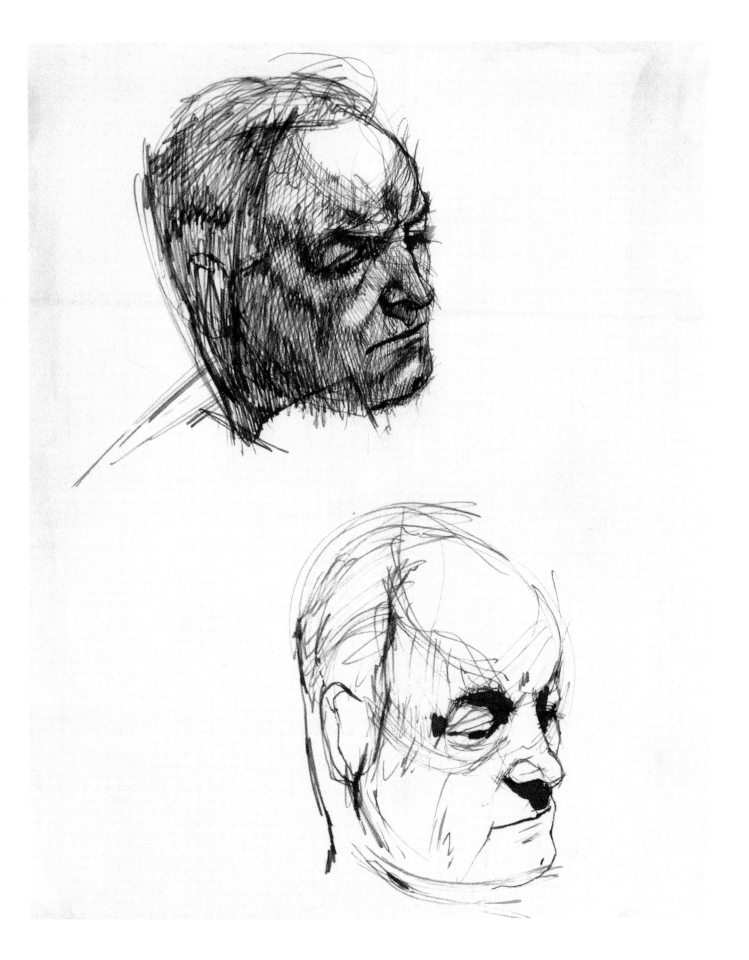

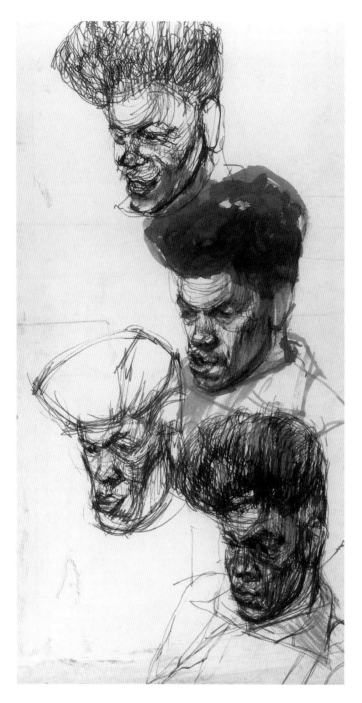

MARINE BROADLEY (1954) (PREPARATORY DRAWINGS)
Pen-and-ink, 12 x 6¹/₂ in (30.5 x 16.5cm)

MARINE BROADLEY (1954) *(Above right)*
Oil on canvas, 20 x 16in (51 x 40.5cm)

This was completed relatively quickly, in around four hours, but following many hours spent making studies of Broadley's head. The more you draw before a painting, the better, because you can solve many problems in the drawing.

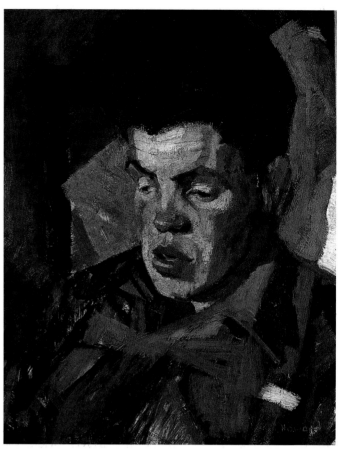

and transferred this tracing on to his canvas – which is a bit like squaring up a drawing for a painting. Canaletto used a camera obscura, which basically consists of a box with a magnifying lens. However, although such mechanical aids can be fun to make and use, they are no real substitute for the judgements of your eye.

I use a pencil or a brush as a simple means of measuring by eye and comparing proportions. And I always draw to a 'module', which means that I select a key part of the subject to use as a yardstick. For a drawing of the figure, for example, I usually take the head as a yardstick and measure the proportion of the head to the body. Dürer took the length of the head as a basic unit of measurement, and some artists find it convenient to use the head fitting into the body about six and a half times as a guide, but this proportion varies between individuals and is something I never take for granted. Drawing is about observable specifics for me, not general rules. Ultimately, accuracy in your drawing rests completely on the accuracy of your observation of the subject.

This was brought home to me when, as a student, I read a statement by the great American draughtsman Ben

Shahn in which he said that when he drew a pair of trousers he wanted people to know whether they were a thirty-dollar pair of trousers or a fifty-dollar pair. *Street Scene in Pokara* is a good example of recording the particular accurately. I was especially pleased that in the short time the children stood watching me draw, I managed to record enough detail to show exactly which part of Nepal each came from.

A plumbline is another useful device for judging vertical lines and relationships. It doesn't involve moving the hand or the arm and therefore it is extremely accurate. If you drop a plumbline between, say, the nose and the feet, or the base of the neck and the feet of a figure, you will get a very accurate idea about how the figure is standing. With practice you will be able to visualize lines like these, and to pick out significant ones and then use them as construction aids.

I often make squared grids on my studio windows and mirrors. These help me to understand the vertical and horizontal relationships in a subject and relate one feature to another. This fitting together of the parts is the most difficult, but the key aspect of drawing.

FIGURE DRAWING AND ANATOMY

The human figure provides the artist with one of the most exciting challenges of all. Because it is so complex and yet so familiar to us, if the various parts are not in the correct proportion or scale to each other, a figure drawing will not be believable.

STREET SCENE IN POKARA (c1978)
Pen-and-sepia wash, 11¹/₄ x 15¹/₄in (28.5 x 38.5cm)

An example of recording the essentials of a subject quickly in order to describe the particular, in this case the exact origin of the four children in the foreground who gathered to watch me draw, each of whom came from a different part of Nepal.

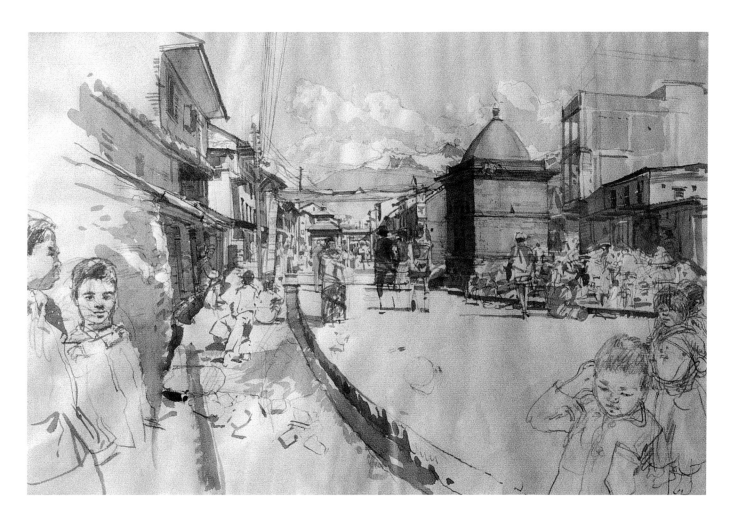

The human figure is full of relationships, both linear and between one curve and another, and it is these that matter most. The flow that runs through a figure gives it life. Drawing the human figure incorporates all the problems that you are likely to encounter with any subject matter and is therefore the best discipline in which to engage if you want to improve as an artist.

As a student I studied calligraphy in my first year. This was a good grounding for figure drawing because even drawing the letter 'A' presents similar problems: for example, the upper part of the 'A' is just as much a shape as the torso of a person. Lettering can also teach you about the importance of the spaces between shapes. An understanding of anatomy, which I also studied as a student, is an invaluable aid to drawing the figure. I would advise studying a book on anatomy to learn about the fundamentals, which will help you to see and express much more in your figure work. You will gain an insight into the underlying structure of the body and how a person moves, though such knowledge should never become a substitute

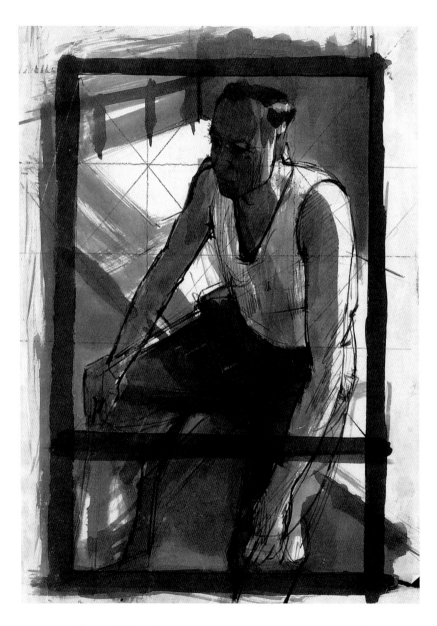

Pen-and-ink sketchbook drawing of Marine 'Wilf' (c1954)

Note how I squared this up in preparation for using it as information for a painting.

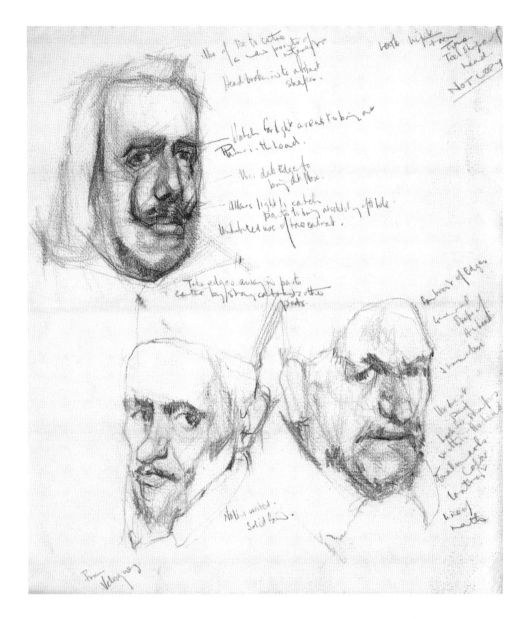

COPYING

DRAWINGS AFTER VÉLASQUEZ
(1950s) Pencil sketchbook studies, 9 x 8in (23 x 20.5cm)

I made various notes to myself here, such as 'Head broken into abstract shapes', 'Take edges away in parts'. Drawing in the sketchbook is all about communicating with yourself, whether you are making marks or writing notes.

for observation. One of the pitfalls of having a detailed knowledge about bone structure, and the way muscles work, is that your figure drawing can become too much a mechanical process; on the other hand, the key clue to an untrained eye is the quality of the figure drawing, and to be able to draw it well demands both knowledge and observation, as well as constant practice.

At a very basic level I started to learn about making drawings by copying those of other artists such as Degas, Vélasquez and Rembrandt. This taught me about two-dimensional shapes, rhythm, the importance of negative shapes (the spaces between shapes), proportion and the relationships between objects.

As a student I copied several of Goya's etchings from his 'The Disasters of War' series, grim and powerful visions expressing the horror of human cruelty. Copying is an excellent discipline for learning about the basics, as long as you copy good drawings – never photographs! When you visit exhibitions you can also learn much more about paintings by drawing from them rather than by simply looking at them. I feel strongly that whenever you visit an

exhibition you should draw from the works that move you, even if only on the back of an envelope.

DRAWING MATERIALS

For pen drawings I use a Gillott 303 dip-pen. The nib is fairly flexible and allows you to vary the pen line by varying the pressure. Never use Rotring pens because you cannot 'lean' on them to obtain the variety of line thickness necessary for good drawing. A cartridge-type fountain pen is also very useful for sketchbook work outside when it can be inconvenient to walk around with a bottle of ink in your pocket. I also use ballpoint pens for sketchbook work, although they are not ideal because the results can be a bit mechanical. For drawing in the studio a straightforward dip-pen and ink are best.

I never draw with an absolutely opaque black line. I like to dilute the ink with a little distilled water. If I go out to draw I use an almost pure ink and also take a bottle of wash that I can use to build up washes gradually towards the darks. You need a good sable brush for this, which you must take care to wash thoroughly. A bottle of watered-down ink, one of ordinary ink, a steel pen-nib and holder, and a No 3 or 4 sable brush are all the equipment you need. Of course it is much easier to carry a pencil in your pocket and I do use pencil for sketchbook work.

I like to draw on a good-quality cartridge paper that is not too textured. For drawing outside I recommend using an A4 or similar-sized sketchbook. I believe you should take one with you wherever you go because it is important to get into the habit of drawing daily, if only for fifteen or twenty minutes. Draw anything and everything. Once you get into a drawing habit you will also get into a 'seeing' habit. It will help you to get your eye in, like the batsman who practises hitting the cricket ball until he sees it so clearly that he cannot miss it. Similarly, as an artist you should practise getting your eye in until every drawing mark you make becomes instinctive and confidently placed.

Drawing practice will hone your observational skills. Whether you are a professional or an amateur, if you want to be a better painter you must devote a certain amount of time every day to drawing.

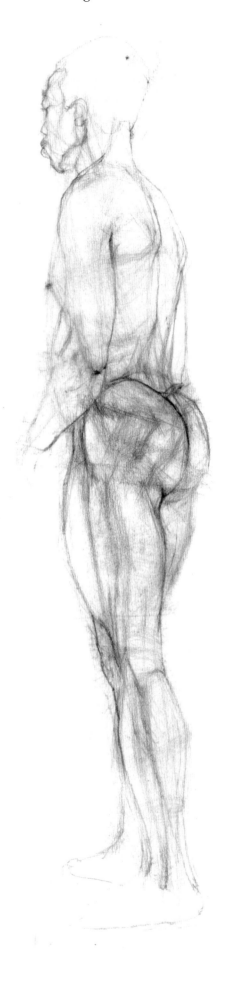

LIFE STUDY (1952)
Pencil, 15 x 5in (38 x 12.5cm)

This early study shows my extensive use of think lines, for example to analyse the buttocks. Note how I arrived at the outside shape by thinking through the form from the 'inside'.

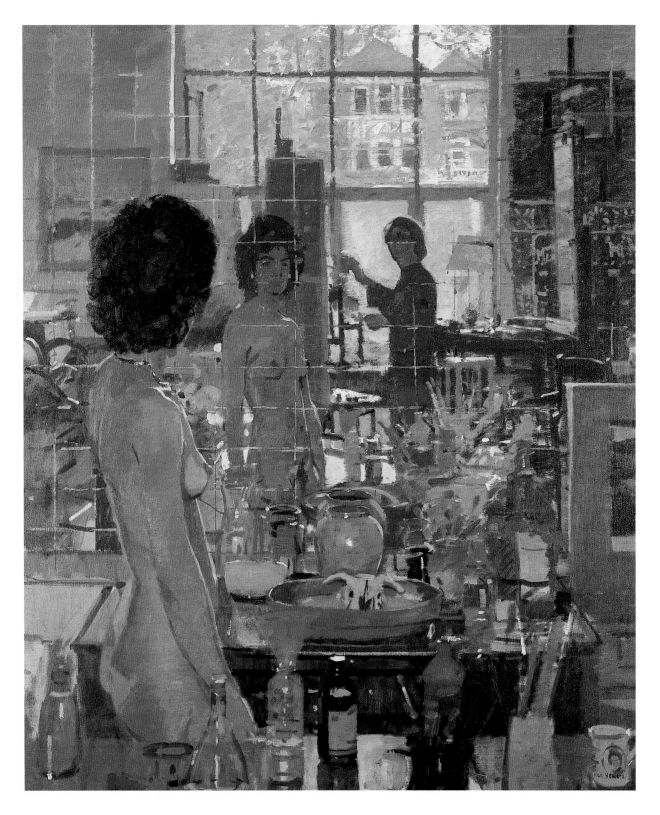

ARTIST AND MODEL (c1985)
Oil on canvas, 48 x 40in (122 x 101.5cm)

*I painted the model and myself from our reflections in the studio mirror,
which is squared up with lines of oil paint, applied with the help of a ruler
to ensure accuracy.*

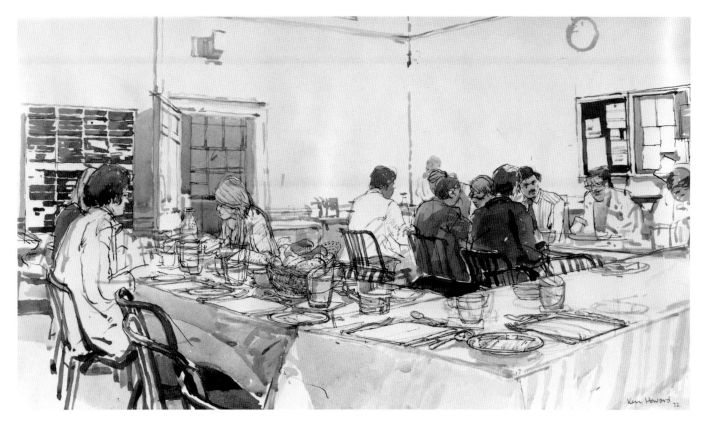

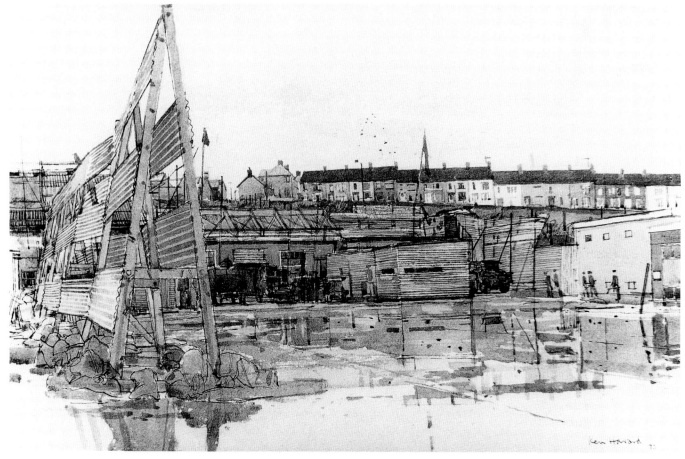

DOCTORS' DINING ROOM AT CHARING CROSS HOSPITAL (1972) *(Top left)*
Pen and wash 11¼ x 15¼in (28.5 x 38.5cm)

Another example of a drawing started with broad washes, followed by pen-and-ink work over the top.

ARMY POST IN THE CREGGAN ESTATE, LONDONDERRY (1973) *(Bottom left)*
Pen and wash, 11¼ x 15¼in (28.5 x 38.5cm)

I loved the strong vertical forms of the barriers on the left-hand side against the horizontal lines of houses and buildings and the reflections in the water on the ground, but because of the inherent danger I was granted permission to work on this drawing only between 5am and 8am – a frightening situation. Because of the rain I had to work from a car, but if you want to make a drawing of a specific composition which has moved you, you sometimes have to put up with uncomfortable circumstances!

ETCHING AFTER GOYA (1952) *(Below)*
4½ x 6¾in (11.5 x 17cm)

APPROACH TO DRAWING

Broadly, there are two kinds of drawing – the complete statement, and the working drawing containing information for further work – although there is not always a clear distinction between the two. The form a working drawing takes depends on how it will be used. The studies of heads (page 14) are part of a series of around fifty pen-and-ink drawings completed as an exploration of its structure before starting the portrait in oils.

When drawing for a painting I start by applying a general wash. The problem in starting with linear marks is the overriding temptation to fill these in. It is much better to start with a wash, and to remember that you are describing three-dimensional shapes. (It is easy to lose sight of this.) A wash can help to describe the overall shapes in a subject and define the main tonal values. This is your first indication. Then you can use your pen to draw into and across the wash – don't make the mistake of drawing around it! Gradually you will become more incisive with

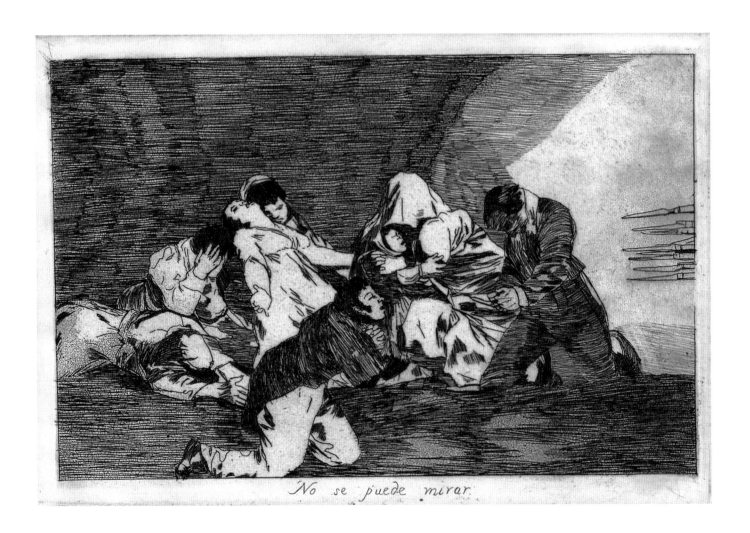

No se puede mirar.

21

the pen until the drawing is 'right'. Degas approached drawing in this way, defining and redefining a subject as the work progressed.

I also often use written notes to remind myself about the details in the subject. For example, I use a system of numbering to explain the range of tones in a scene, from the lightest, 1, to the darkest, 6. Or I might describe the colours in order to rekindle my memory of them when I start to work from the drawing for a painting. This may not be especially illuminating to anyone else, but to me it is invaluable information, a collection of references to which I can turn in order to rediscover my experience of the original subject when working in the studio.

You can also use a drawing to tell you the exact compositional breakdown of a subject. For example, when you draw an architectural subject you can indicate the main proportions with numbers, or allow a grid of reference to develop in the drawing as you go along, using the main verticals and horizontals in the subject as a base. It also helps to select something in the subject to act as a module against which you can relate and measure everything else. This will give your drawing unity; all parts will relate to each other and to the whole – but the whole must be broadly established first, before selecting the module.

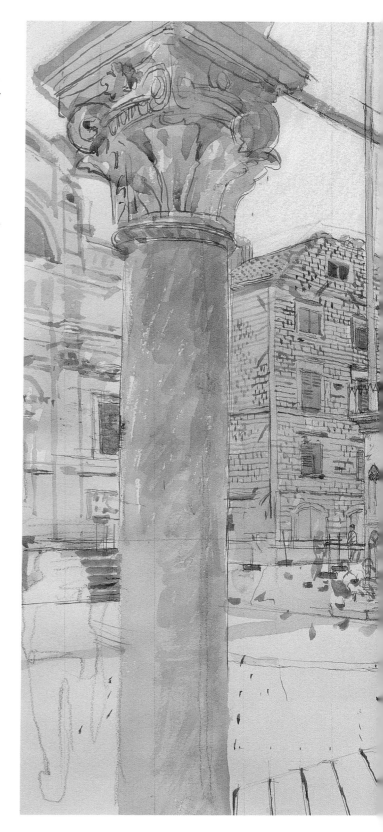

THE STADIUM, DUBROVNIK (1996)

Pen-and-sepia wash, 14 x 20in (35.5 x 51cm)

One of a series of drawings commissioned to help raise funds for the restoration of the historical monuments of Croatia. I took a very wide angle of vision and decided on the vanishing point on the right-hand side at the outset, otherwise each time I moved I might have over-complicated the drawing by including different vanishing points to reflect my new centre of vision. Taking such a wide-angled view can make drawing difficult, yet this is one of the advantages the artist has over the camera. I used pencil to sketch in the main compositional lines first, then added washes to define the different areas of tone before drawing with the pen and building up further tonal washes.

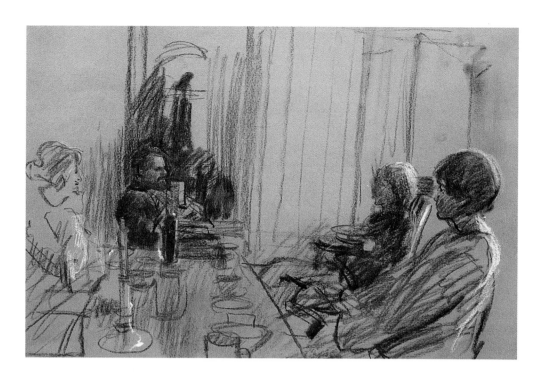

SITTING AT BREAKFAST IN CORNWALL (c1979) *(Above)*
Charcoal and white chalk on tinted paper, 11¼ x 15¼in (28.5 x 38.5cm)

*Your visual senses should be alert at all times because good subjects are all
around us. I encourage students to draw from their immediate surroundings
whenever they have the opportunity, as I did to capture this intimate scene.*

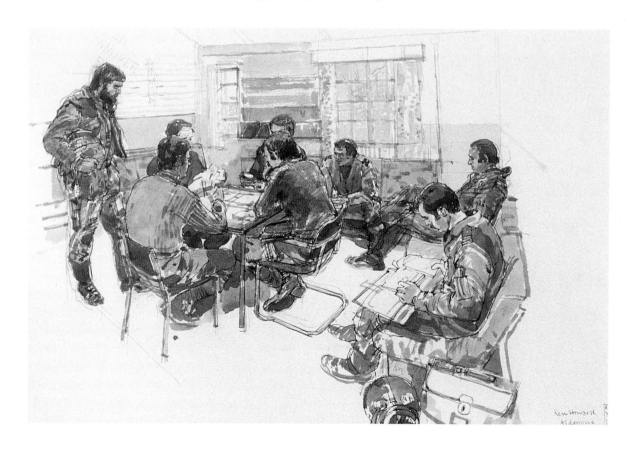

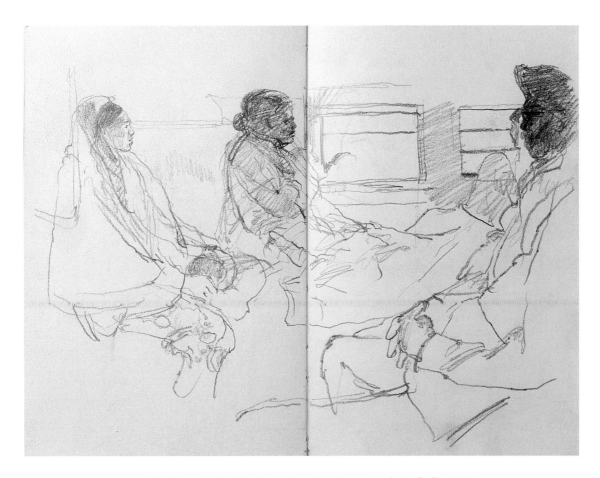

Quick pencil sketchbook studies of people on a train in India, 1986

TELEPHONE DIRECTORY DRAWING (c1970)
Pen and ink, 6¹/₄ x 7¹/₄in (16 x 18.5cm)

From the late 1960s to the late 1970s the Post Office Telephone
Directories *were illustrated with commissioned line drawings by
young artists, of which I was one. These had to be done purely with
pen-and-ink lines – no washes. This provided a useful income and
in addition it was a tremendous discipline. I would visit a town, or
area, start drawing before breakfast to get my eye in, then after
breakfast work on several more detailed drawings before moving
on to the next location. By the end of each day I produced much
better drawings than the first one!*

HELICOPTER CREWS WAITING (1973) *(Left)*
Pen and wash, 11¹/₄ x 15¹/₄ in (28.5 x 38.5cm)

*I developed this drawing part by part, by drawing one figure in
relation to the next before letting the first one leave. I used the first
figure as the module for the whole drawing: fitting together the
parts in correct relationship with each other, and with the whole
composition, is what drawing is all about for me.
(Reproduced by courtesy of the Imperial War Museum.)*

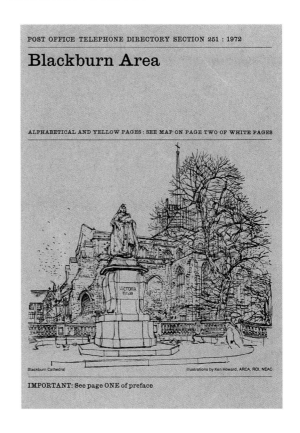

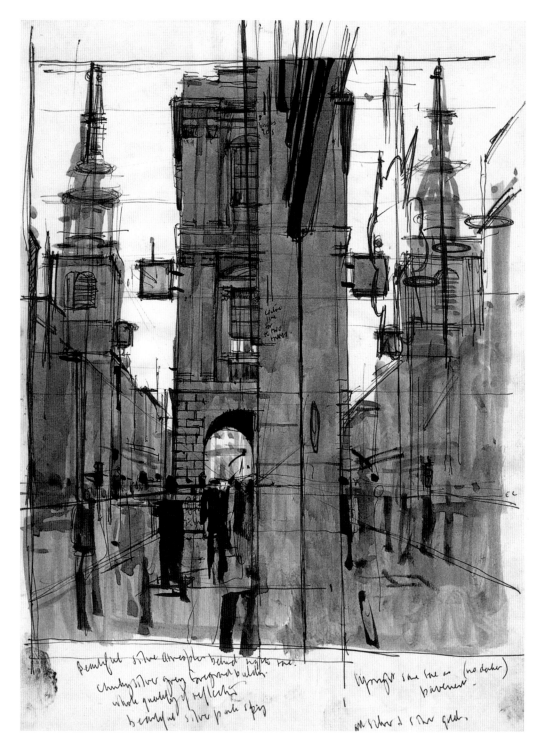

SKETCHBOOK STUDIES FOR CHEAPSIDE

For cityscapes and for outdoor subjects in particular, I like to establish my eye level early on in the project because, as it is a true horizontal, all other angles can then be judged against it. It is far better to include too much information and detail in a working drawing than too little, because you then have the opportunity to sift the information you collect and edit out whatever is extraneous to the painting – although of course the way you work from drawings will develop with experience and become personal to you.

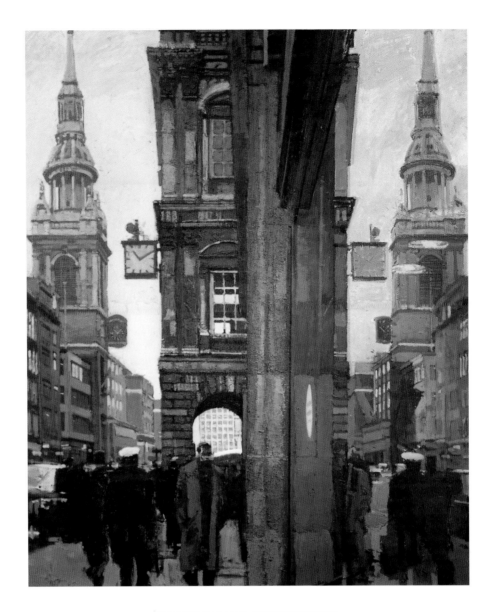

CHEAPSIDE, 10.10AM, FEBRUARY 10 (1970)
Oil on canvas, 72 x 60in (183 x 152.5cm)

SQUARING UP

If you have spent a lot of time on a drawing and on solving various compositional problems, there isn't much point in spending an equal amount of time trying to redraw it on a canvas. I will often square up my drawings in order to transfer the basic information to my canvas, ready for painting – it is important, of course, to ensure that the proportions of the drawing are equivalent to the proportions of the canvas – and I don't worry about getting rid of any remaining visible grid lines once the painting is finished, either.

One of the dangers of squaring up, however, is to forget that this is only the first step towards the painting. Drawing is an inseparable part of painting and whenever you apply a brushful of colour to a canvas you are still drawing. The drawing and questioning should continue with every application of colour until the painting is finished. The greatest problem is when a painting 'closes down' on you and the surface becomes dead. To avoid this you must work hard to keep the drawing alive, right up to the very last mark, which should express the same excitement as the first one made.

WATERCOLOUR

One of the appealing qualities of watercolour is its transparency, which makes it an ideal medium for capturing the subtleties of different light effects in nature. The (normally white) surface of the paper reflects back through the colours, giving them their wonderful luminosity. It is a fluid medium – a great friend at Harrow School of Art regarded painting in watercolour as 'pushing a puddle around' on your paper; my own approach is to think of the medium as an extension of drawing, as a way of getting down information rapidly, and I work in a relatively controlled way, using less water than in wet-in-wet techniques.

Another attraction for me is that, like drawing, watercolour demands that you give enough information but leave enough room for the observer to complete the scene in their imagination. The best watercolours are those which say the most with the fewest means. In addition, a great advantage of the medium for someone who enjoys travelling is its convenience: all you need is a small portfolio in which to transport your paper, a light-weight board, and your watercolour box, brushes and waterpot, all of which will fit into a light haversack – ideal for the itinerant artist.

BEACH FAMILY AT MARAZION (1996)
Watercolour, gouache and pastel, 10 x 15in (25.5 x 38cm)

I started with transparent washes, added more opaque colour for the sand and figures in the foreground, and finally applied broad strokes of pastel across the area of sand to modify the colour and create a lovely textural effect.

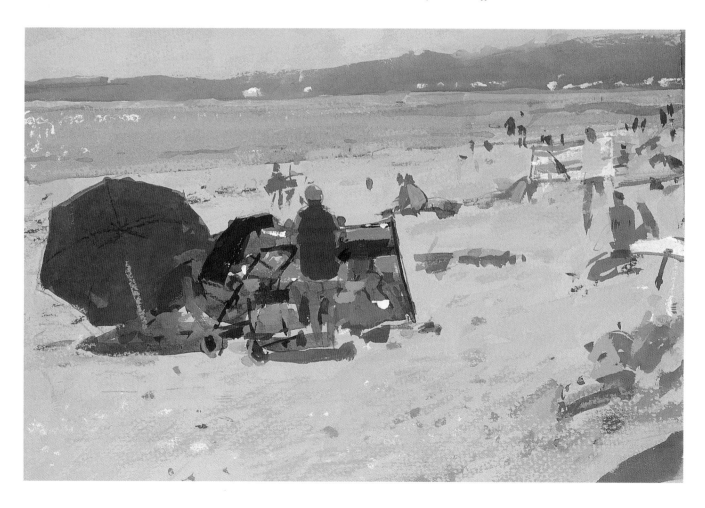

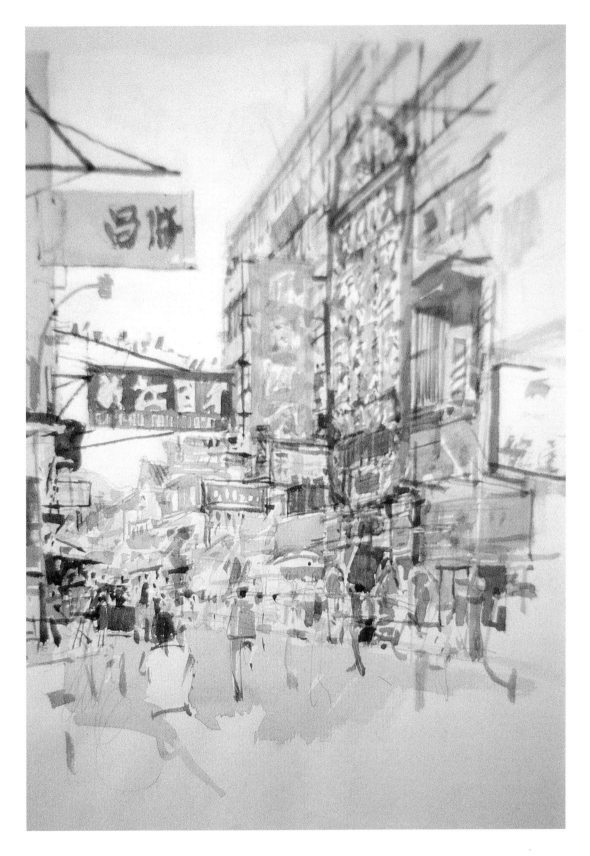

STREET SCENE IN HONG KONG (1996)
Watercolour, 10 x 7in (25.5 x 18cm)

*Happily I was forced to stop work just at the right moment when a van
parked and obstructed my view twenty minutes after starting the painting.
In that short time I was able to suggest the hustle and bustle of movement
amongst the foreground figures without fully describing them.*

AN EARLY START

I started working with watercolour as a student at Hornsey School of Art (from 1949 to 1953). Every weekend during my first year we were given a subject to paint in watercolour on a half-sheet of imperial paper (15^1/$_4$ x 11^1/$_4$in/38.5 x 28.5cm), which is quite large for a watercolour painting, so I learned a great deal about the medium at the start of my career. For example, I learned that, unlike oil paint which can be pushed around, scraped off, and corrections made, there is only a certain amount of manipulation possible with watercolour before you damage the surface of your paper and, worse, destroy its wonderfully fresh, transparent quality.

When I left Hornsey School of Art I didn't use watercolour again until I went to Northern Ireland in 1973, where I used it to add colour to my pen-and-wash drawings. It was convenient to use in difficult circumstances because it is such an immediate and flexible medium – quick both to set up and to put away. Later, after visiting Venice for the second time (in 1978 – my first was as a student in 1959) and failing with my first few oil paintings, I went back with my watercolours and discovered that because of its transparency, watercolour is perfect for capturing light effects and reflections on water – in other words it captured the whole 'feel' of the place for me. So when I travel to places like Venice, I recharge my watercolour box with half-pans of Winsor & Newton artists' quality paints, and take a tube of each colour as well, in case I use up the colours in my box.

The quality of the paint, indeed of all your materials, is more critical with watercolour than with oils, partly because the medium is more 'delicate' or 'precious'. I would never use anything other than artists' quality paints. My palette of colours is broader in the number and types of colour than my oil palette. It consists of: aureolin, raw

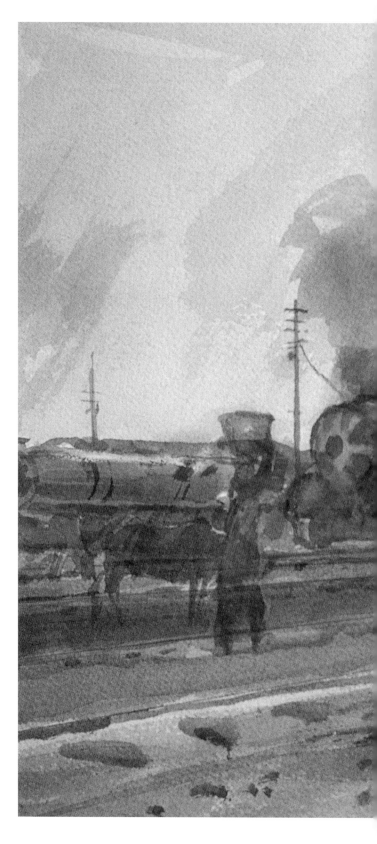

THE RUNNING SHED, LUCKNOW (1986)

Watercolour and Chinese white, 12 x 16in (30.5 x 40.5cm)

When I visited India I had been working in pure watercolour, but with this return to my beloved railway subjects I realized the necessity of working with semi-transparent colour and Chinese white in order to get the marvellous sensation of steam and smoke, which have always been great inspirations for me. One of the hazards of working in India is the wildlife: on this occasion I lost brushes worth fifty pounds when the monkeys who inhabited the roof of the running shed made a lightning strike!

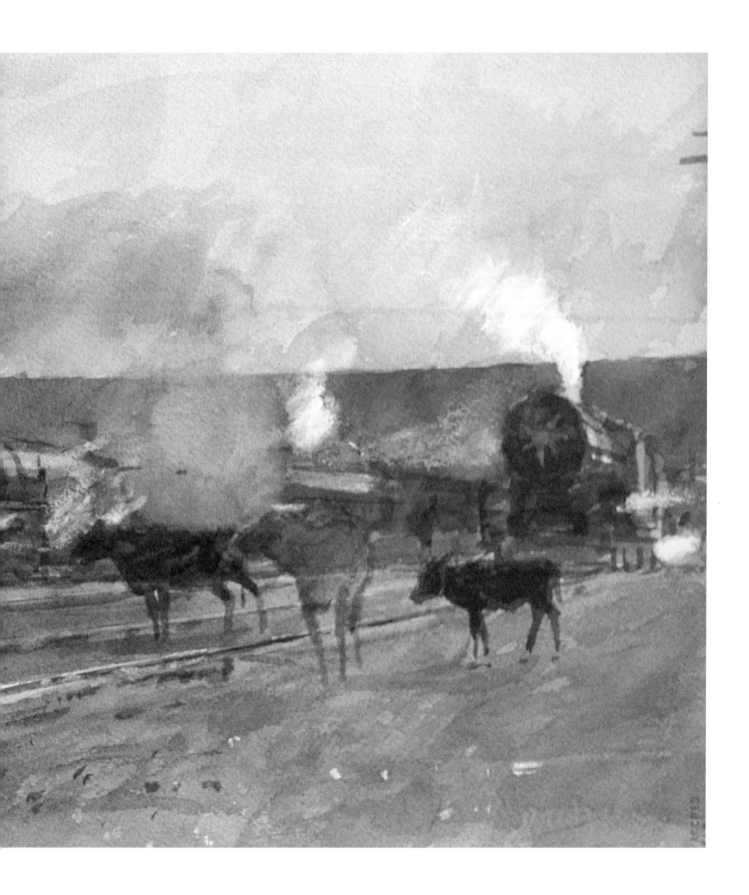

sienna, yellow ochre; cobalt blue, cerulean, ultramarine, Winsor blue and Prussian blue (I use fewer blues in my oil palette); cadmium red, alizarin crimson, light red and Venetian red; raw umber, burnt umber, burnt sienna, and a tube of Chinese white – a dense, cool white which will render transparent colours opaque or semi-opaque when mixed with them.

USING BODY COLOUR

I use Chinese white (body colour) for picking out the lights, especially when I paint in Venice. Hercules Brabazon (1821–1906), who for me is one of the great watercolourists, used a lot of Chinese white, like Turner, with stunning results. Brabazon was adept at paring down his subject to the essentials and painting with transparent colour with rich accents of body colour.

I make more extensive use of body colour for paintings of subjects where there is a lot of movement, for example on the beach in Cornwall during the summer when the subject changes frequently as people come and go. It becomes necessary in these circumstances to be able to paint out figures; indeed some figures in these watercolours become amalgamations of several different ones. Moreover, the contrast between opaque lights and rich, transparent darks helps to express the intensity of the light. (A pure transparent watercolour painting approach would be too restrictive here, although in Venice, Prague, Morocco, the Yemen and Israel, places in which the light is intense and movement less apparent, I revert to a pure watercolour technique.)

INTERIOR AT FORK HILL (1978)
Pen and wash and watercolour, 11¼ x 15¼ in (28.5 x 38.5cm)

I approached this painting in a similar way to an oil painting by establishing the broad distribution of tone with pen and wash first, after which I built up the colour with glazes of watercolour.

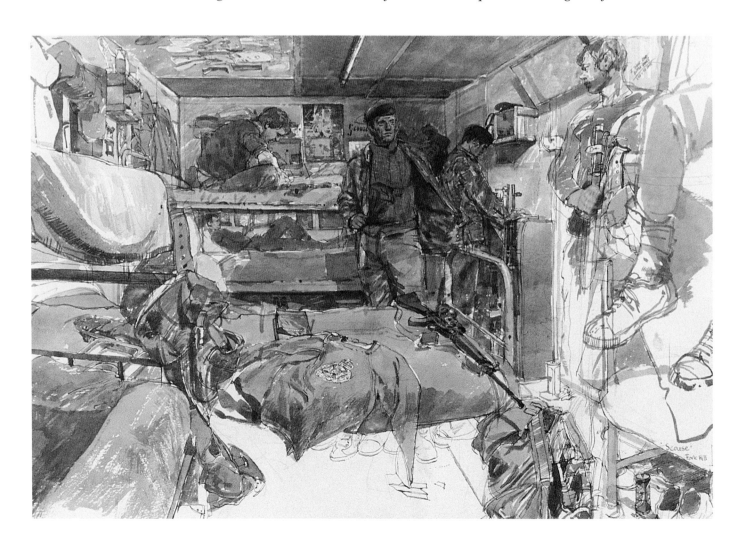

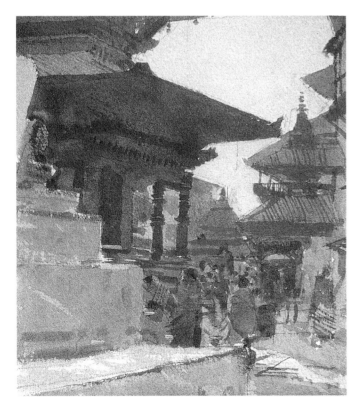

STREET SCENE IN DELHI (1984) *(Above)*
Pencil and watercolour, 5 x 7in (12.5 x 18cm)

Watercolour is an evocative medium and ideal for giving people just enough clues to form an impression of a place. What you leave out can be as important as what you include in a painting, and although I have left a great deal unsaid here, I hope I have nevertheless conveyed the hurly-burly bustle of this scene.

EARLY MORNING, KATHMANDU (1978) *(Left)*
Watercolour, 5 x 7in (12.5 x 18cm)

I was so excited by this magical place that I couldn't sleep at night. A pure watercolour approach was ideal for capturing the wonderful silvery grey sparkling light effects.

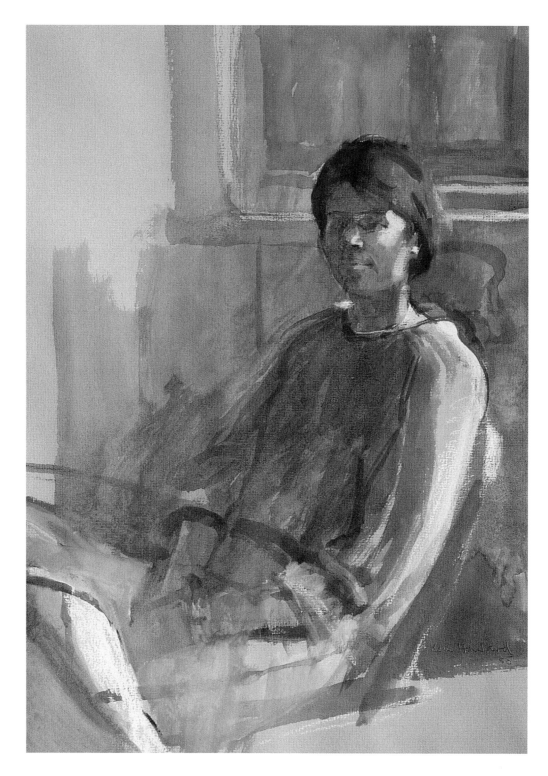

VISITOR AT ST CLEMENT'S HALL (c1988)
Watercolour, Chinese white and pastel, 12¹/₄ x 8³/₄in (31 x 22cm)

*I felt completely uninhibited by my materials in this painting, especially
when painting the head. In fact, my best portraits have been painted in
watercolour, probably because the technique of painting with superimposed
washes encourages a less detailed approach and results in portraits which
seem to be more evocative and exciting.*

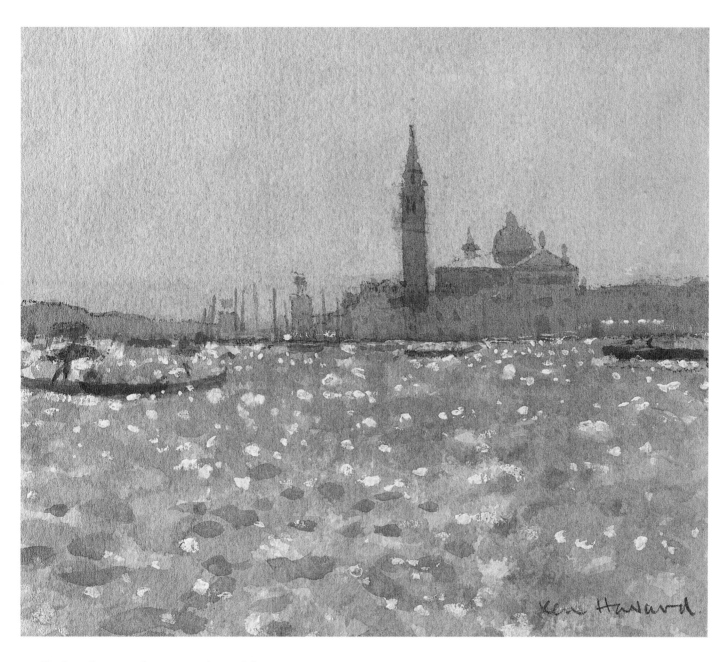

Body colour can be extremely useful in many circumstances, but remember that, if you do introduce Chinese white into your watercolour palette, you must learn how to control it, otherwise it will permeate everything and deaden your painting.

PIGMENTS AND PAPERS

In places where the light is intense I work mainly with transparent colours, which allow the reflective surface of the paper to shine through and which are perfect for describing the atmosphere, space and light of the subject. My basic colours in these situations are raw sienna, burnt sienna, burnt umber, raw umber (although this can be a

VENICE: S GIORGIO MAGGIORE, JULY (1997)
Watercolour, 6³/₄ x 8in (17 x 20.5cm)

To achieve the sky I applied a series of pure transparent layers of colour, one over the other, each wash being allowed to dry before the next was added. Superimposed washes of thin colour result in more resonant areas of colour than a single, dense, flat wash. Here I used raw sienna, ultramarine and alizarin crimson in very thin glazes, heavily diluted with water, and ran the same colours through the water in the foreground before applying Chinese white to pick out the reflected lights.

difficult colour to use pure), aureolin, Winsor blue, ultramarine and alizarin crimson – all transparent colours. The opaque colours are more useful for dull, rainy days when I also use more Chinese white. Then I use more yellow ochre, cerulean, cadmium red, light red and Venetian red. I never use black in watercolour painting: it is a dead colour for me.

For pure watercolour painting I use heavyweight 400lb (800g) rough-surface (Not) Arches paper. I love the feel of it; it carries washes without undue absorption and you don't have to stretch it if you prefer not to. For paintings in which I might use a lot of body colour, or mixed-media techniques including gouache and pastel, I work on Fabriano papers, often on a tinted colour, which is similar to working on a coloured ground in oil painting.

OLD SANAA, YEMEN (1997) *(Right)*
Watercolour, 12¹/₂ x 11³/₄in (32 x 30cm)

Leaving a large area of bare white paper can act as a foil to the other colours and give a painting a sense of atmosphere and 'airiness'. One problem highlighted here, however, is the unhappy relationship between the greens and the rest of the painting – they do not harmonize as I introduced them too late in the painting.

SOUK IN MARRAKESH (1996) *(Below)*
Pencil and watercolour, 9 x 12in (23 x 30.5cm)

A good example of the glazing technique in which rich colours have been built up by the superimposition of one transparent colour over another in order to express the incredibly bright light. Note how I plotted the main shapes and compositional arrangement in pencil first.

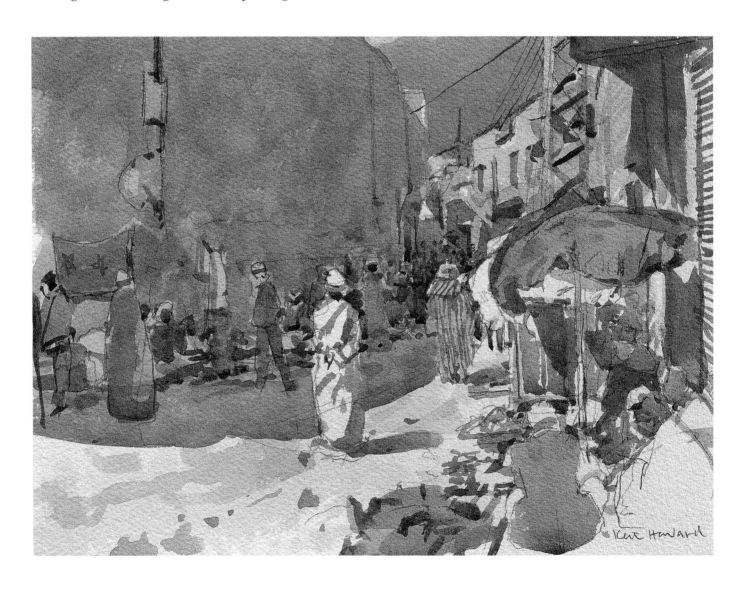

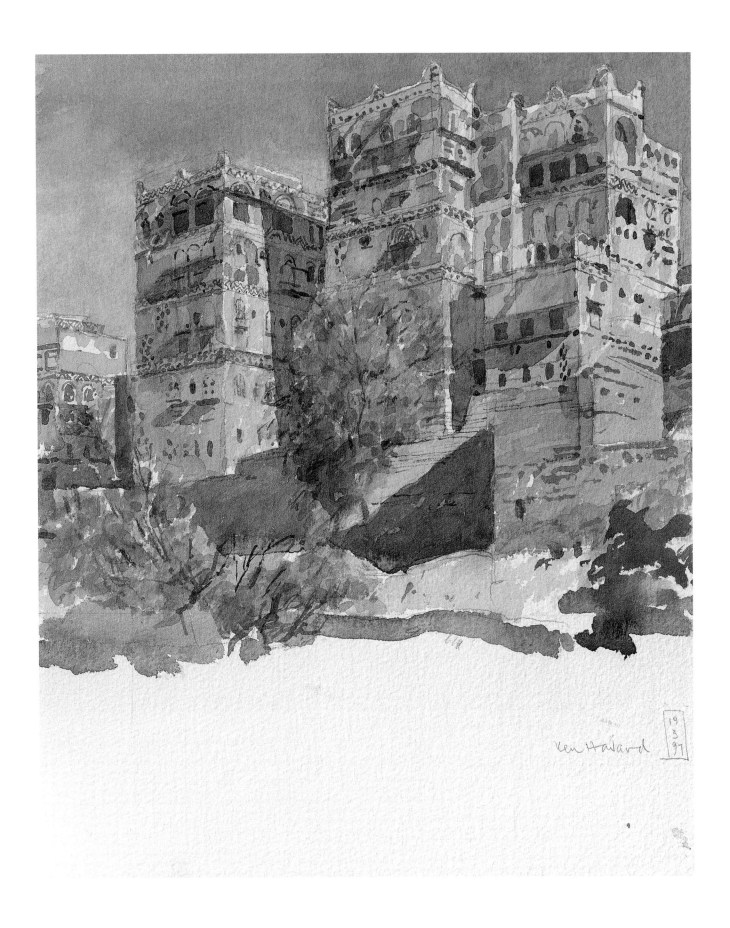

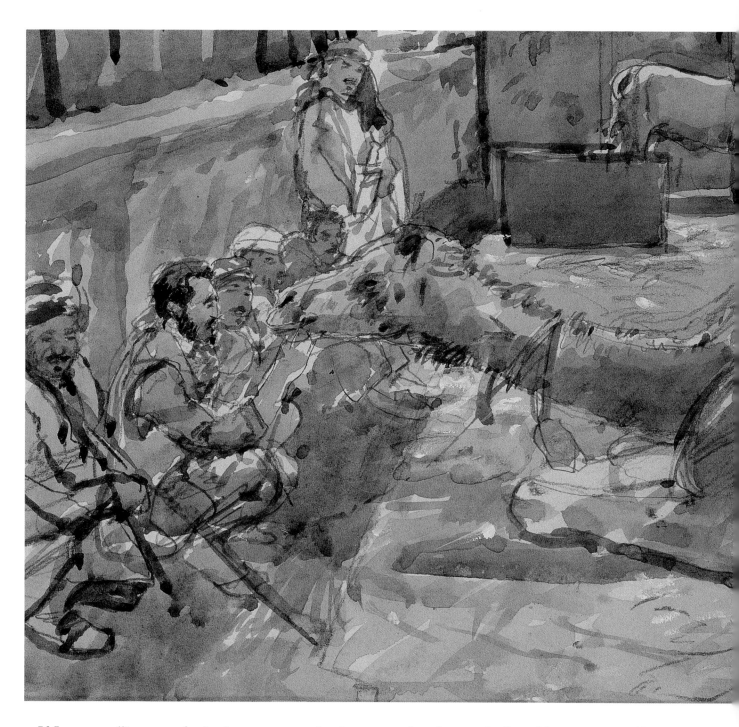

If I am travelling to a destination so as to paint in watercolours specifically, I stretch a couple of sheets of paper on either side of a board the night before; if I don't do this I work on unstretched paper. Undoubtedly it is preferable to work on stretched paper, especially if you favour a wet-into-wet wash technique. However, because I don't work with very wet washes I don't experience many problems with cockling. Besides, it is quite possible to rescue a painting which has cockled by damping the back thoroughly, and then taping the painting to a board with water-based gumstrip. Stretching paper is itself an art and it requires practice to know exactly how wet to make the paper, when to apply the gumstrip, and what thickness of board and tape to use. Unstretched paper is more convenient, but I still fix it to my board with masking tape all the way round. This has two advantages: it helps to prevent cockling, and it also encourages you to work right up to and over the edges of the tape, so that when you take it off you are left with the 'framed' rectangular watercolour painting with four edges.

CAMELS IN THE MARKET AT SANAA (1997)
Pencil, watercolour and Chinese white, 6¹/₂ x 14in (16.5 x 35.5cm)

I often work 'sight size' in watercolour, so my paper is usually around 8 x 10in (roughly 20 x 25cm). If you work on too large a scale a watercolour can lack the necessary tension between areas that pulls the painting together. Yet another drawback, of course, is that in hot climates it is difficult to control large washes because they dry so quickly. However, many of the finest watercolours have been painted on a small scale – note the wash drawings of Rembrandt or Goya, Turner's sketchbooks, or Cotman's watercolours.

I added an extra piece of paper on the right-hand side to extend the drawing, which is another advantage of drawing and watercolour painting – you cannot do this with oils. I drew with pencil initially because the camel was a new and complex subject and I needed to explain and understand its form. The colour doesn't necessarily follow these pencil lines because with each application of line or colour I was trying to make my representation more accurate.

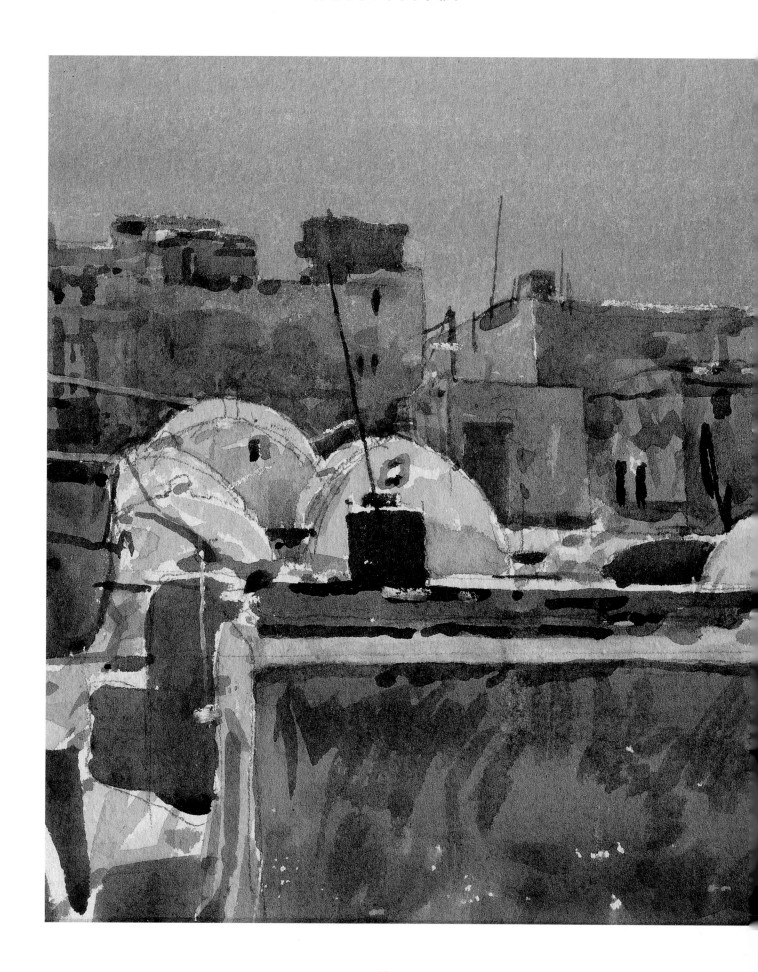

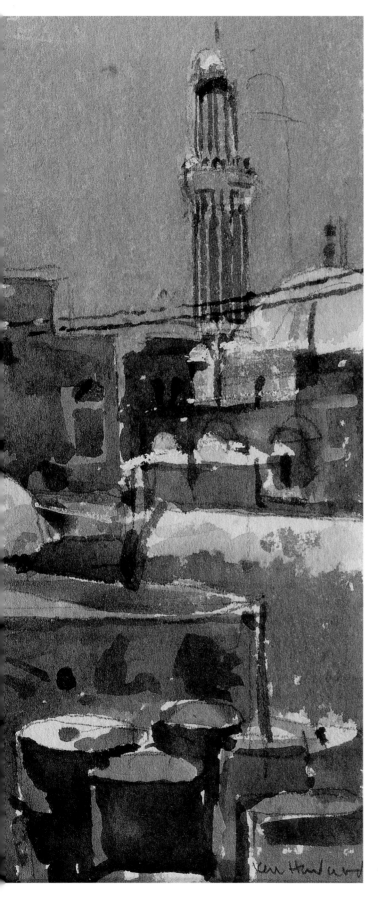

BRUSHES

Watercolour brushes should be the best quality you can afford to buy. A good one will last a very long time. I use Kolinsky sable brushes and take great care in looking after them properly, which means rinsing and drying them thoroughly with a rag or kitchen paper before putting them away. If they are still damp when you put them in a box or container they will lose their resilience and responsiveness, and these are crucial qualities for watercolour painting.

There are many different shapes available but most of the time I use round brushes, from size 6 upwards. These are best for broad washes, and because sable hair tapers naturally to a fine point they also offer maximum control and the opportunity to draw into the washes in a technique similar to line-and-wash drawing. Occasionally I use a flat brush (also known as a 'one stroke') which, because of its square end and high colour-carrying capacity, allows me to lay in a relatively large sky area.

A simple way to protect brushes from damage when travelling is to lay them in a piece of corrugated paper, then roll this up and secure it with a couple of elastic bands. Alternatively, buy a proprietary brush holder – I use one made by Winsor & Newton.

COLOUR MIXING

I love to build up wash over wash of colour to achieve the wonderful luminous quality unique to watercolour. In my experience it is best to do your colour mixing by glazing one colour over another, although I do mix on the palette as well, in which case I try to restrict myself to only two or three in each mix.

PUBLIC WASH HOUSES, SANAA (1997)
Watercolour and Chinese white, 9 x 12in (23 x 30.5cm)

The sky in the Yemen is an intense blue and much more opaque than in Venice. Here I used a wash of cobalt blue overlaid with a wash of light red to suggest its intensity. I built up the darks in the foreground with several washes, damping the dry colour on the paper first to keep the colours reasonably luminous.

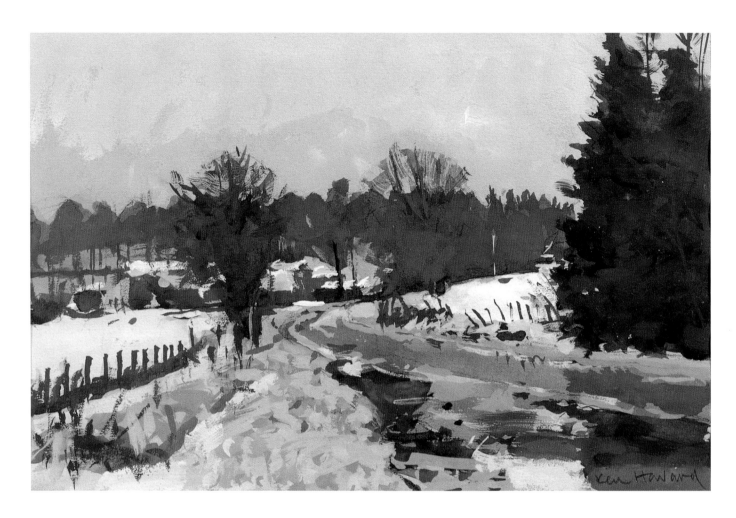

One problem with building up your darks by glazing colours on top of each other is that when you add your second or third wash the colour starts to become opaque or muddy. I have discovered, however, that if you dampen the dry colour on your paper before applying the second or third wash, it will retain some of its transparency. Of course, the fewer the layers of paint you apply the more delicate and fresh the painting will be.

The more practised you become with watercolour painting, the more instinctive your technique will be. It is important that you take charge of your medium, never allowing it to control you. Even though it is a technical medium and there appear to be many rules to observe, ultimately you should feel free to do whatever seems appropriate in order to say the things you want to say. Respect the medium certainly, but try to avoid becoming too hidebound by technique.

My late wife, Christa Gaa, was a marvellous water-colourist because she was totally uninhibited by the medium; I learned a lot from her. Christa used watercolour instinctively and I have always maintained

SNOW NEAR ABERDEEN (1996) *(Above)*
Watercolour and Chinese white, 6³/4 x 10¹/4in (17 x 26cm)

For winter subjects my watercolour palette becomes more limited, although I still do not use any black – I prefer to use Winsor blue to darken colours. Mixing Chinese white with colours is ideal for creating semi-transparent, slightly milky effects that are particularly effective for wintry, snow-filled skies and the more opaque qualities of winter colours.

WAILING WALL, JERUSALEM (1997) *(Top right)*
Watercolour, 10¹/2 x 13in (26.5 x 33cm)

There is no initial drawing in this watercolour; I started straight away with broad washes of colour. Working in this way prevents you from being tempted to 'fill in' with colour.

MORNING LIGHT, YEMEN (1997) *(Bottom right)*
Watercolour, 7 x 10³/4in (18 x 27.5cm)

The play of warm and cool colours conveys the effect of light and pulls areas together. I lifted off opaque dark colours with a damp tissue because once the transparency of watercolour is lost it starts to 'die'.

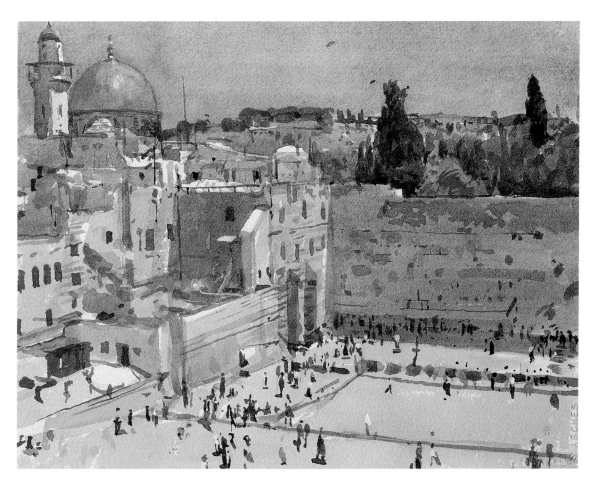

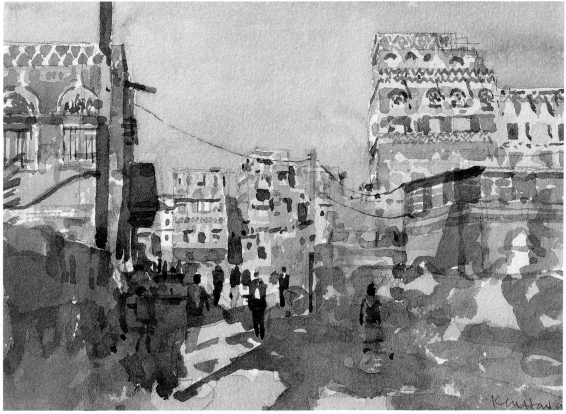

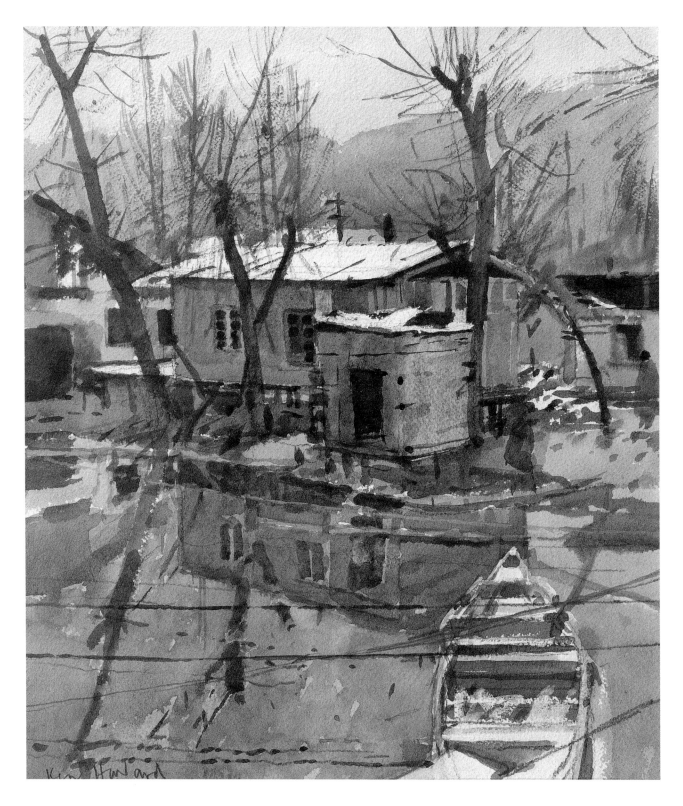

WINTER IN KASHMIR (1984)
Watercolour and Chinese white, 12 x 10¹/₂in (30.5 x 26.5cm)

*I tried to leave the paper bare for the lightest tones, although I didn't
always succeed. I was concerned especially with the different tone and
colour values between the reflections and the actual objects.*

that with watercolour painting it is a question of finding an *equivalent* representation of how you see the subject as opposed to a faithful rendition of it. For example, because of its transparency and the fact that it dries to a lighter shade when used as gouache, it is impossible to match the exact values of the things you see in watercolour. This is very different from oil painting, in which the tone values are rather like the notes on a piano – you can control the sequence all the way through the development of a work.

A wet-in-wet technique can be effective for painting skies, and although I generally avoid using too much water I do sometimes run one colour into another to create a graded wash for a sky, moving gradually from cool to warm depending on the position of the sun. Working wet-into-wet is tricky, though, and it takes experience to know how wet to make the paper or how strong the washes should be in order to control the spread of the paint. The

angle of your board is also important and will affect how the colours run down the paper. When I sit to paint I like to hold my board between my knees so that I can adjust the angle immediately colours begin to get out of control.

On the whole, however, I prefer to work wet-on-dry by applying transparent layers one over the other, each wash being allowed to dry before applying the next one. For example, for a warm Venetian sky I might apply a wash of dilute yellow ochre or raw sienna; once this is dry, I would probably superimpose a wash of ultramarine and use a

SURFERS, SENNEN (1996)
Watercolour and Chinese white, 8 x 10in (20.5 x 25.5cm)

A good example of the effectiveness of using Chinese white to suggest the shimmer of light on water.

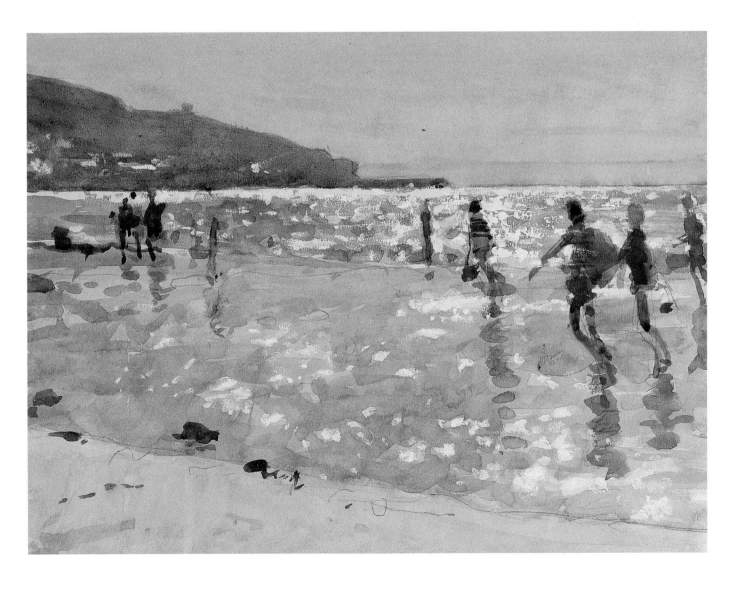

sponge to lift off some of the colour near the horizon line where I might want the sky to be warmer.

I like to complete a watercolour in one sitting, in what I call 'one wet'. To return to the same painting the next day would mean painting in another rhythm and the work would lose that essential unity which a watercolour needs.

RESERVING THE LIGHTS

I like to try to preserve the white of the paper for my lightest areas, but this requires careful planning and often I am so busy applying my wash and thinking about a myriad other things that I forget to do this. In these instances I might lift out colour from the paper while it is still wet, using a sponge or tissue paper, or use Chinese white at the end of the painting to win back the light accents. I also use a craft knife to scrape out tiny areas – although this can only be done on paper as robust as the heavyweight Arches I generally use. I never use masking fluid, which is fine for graphic designers, but as a technical process is too mechanical for me.

UNPREDICTABLE EFFECTS

Sometimes the best watercolours happen by accident, and I believe it is important to be aware not only of the predictable effects which you can create and control, but also the fortuitous effects that can occur when you feel out of control.

I often fall into a state of despair with a watercolour painting. Sometimes when this happens I take drastic measures by throwing water over the entire painting and waiting for it to dry. This takes off the surplus paint and revives the purity and transparency of the colours, lost by too much overworking. It can also create unusual effects which you could never repeat or explain, but which you should accept as part of your struggle with the painting. As Francis Bacon said: 'Perhaps one could say it's not an

TRAWLERS AT NEWLYN (1988)
Watercolour and Chinese white, 9 x 7in (23 x 18cm)

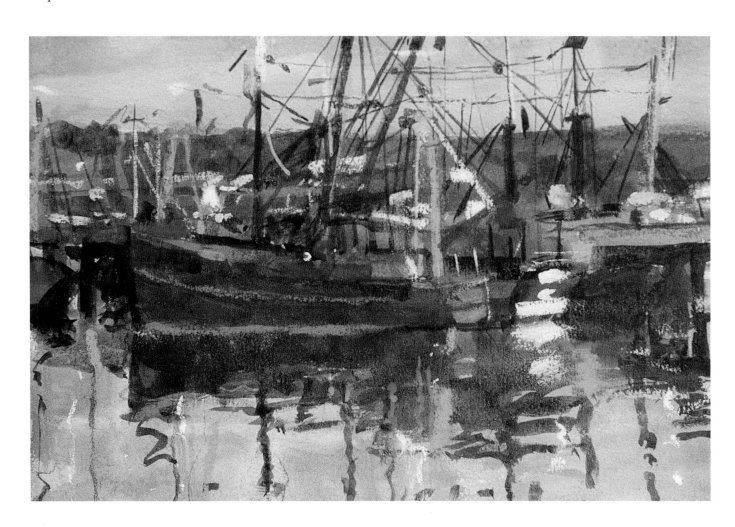

accident, because it becomes part of the process which part of the accident one chooses to preserve.'

I dislike 'run-backs' but, again, if this happens it is best to leave them. Often you can make these into something else that will play a positive role in the painting. This is similar to leaving all your marks in drawing, even the so-called 'mistakes'.

If you feel that you have lost your painting irretrievably and there is nothing you can do with watercolour or gouache to redeem it, you can always work into it with pastel to bring in an extra accent of colour or light. (This must be a last resort, of course, because if you try to work with watercolour over pastel the pastel will act as a kind of resist and you will get into all kinds of problems.)

The unexpected things that can happen when you mix pigment and water on paper can be magical, but they also highlight the fact that when you paint in watercolour you must concentrate one hundred per cent. Sickert used to say that if an artist spent two hours fully concentrating on a painting he had done a full day's work, and while I feel that I can spend ten hours on an oil painting and still feel positive about it, with a watercolour painting I feel I am walking a tightrope between success and failure. When it is finished I am often exhausted. As a medium, watercolour is much more demanding than oils.

APPLES AND REFLECTIONS (c1985)
Watercolour and pastel, 8 x 10in (20.5 x 25.5cm)

This subject is very ordinary – the sort of thing we see every day without noticing it. It is the task of the artist to make the ordinary extraordinary.

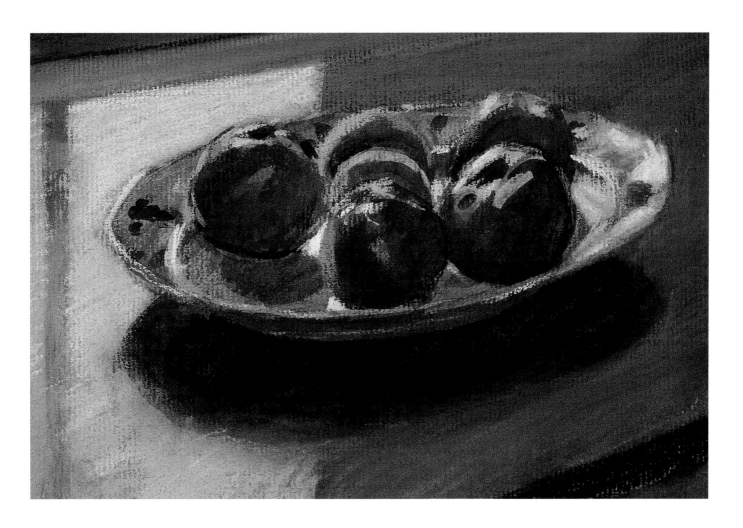

CLOSING THE GAP WITH OILS

I paint in watercolours for about one third of my time; my ambition eventually is to close the gap between watercolour and oil painting in terms of technique and perception. Currently, watercolours are undervalued relative to oils: collectors think that watercolours should be less expensive, for example, yet a small watercolour can have as much power as a large oil painting. One of my goals is to exploit the incredible variation of transparency, opacity and textural effects possible in watercolour and apply a similar approach to working with oils so that the two media are much closer together in terms of technique – one practice informing the other. I hope that you will be similarly inspired.

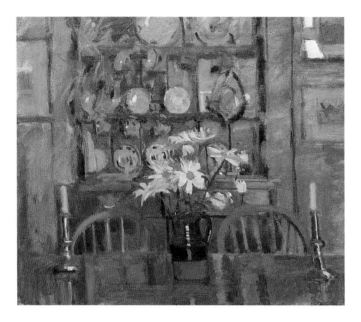

THE WELSH DRESSER (1989) *(Above)*
Watercolour and Chinese white, 10 x 12in (25.5 x 30.5cm)

FROM THE OLD HARBOUR, NEWLYN (1987) *(Right)*
Watercolour and Chinese white, 6 x 4in (15 x 10cm)

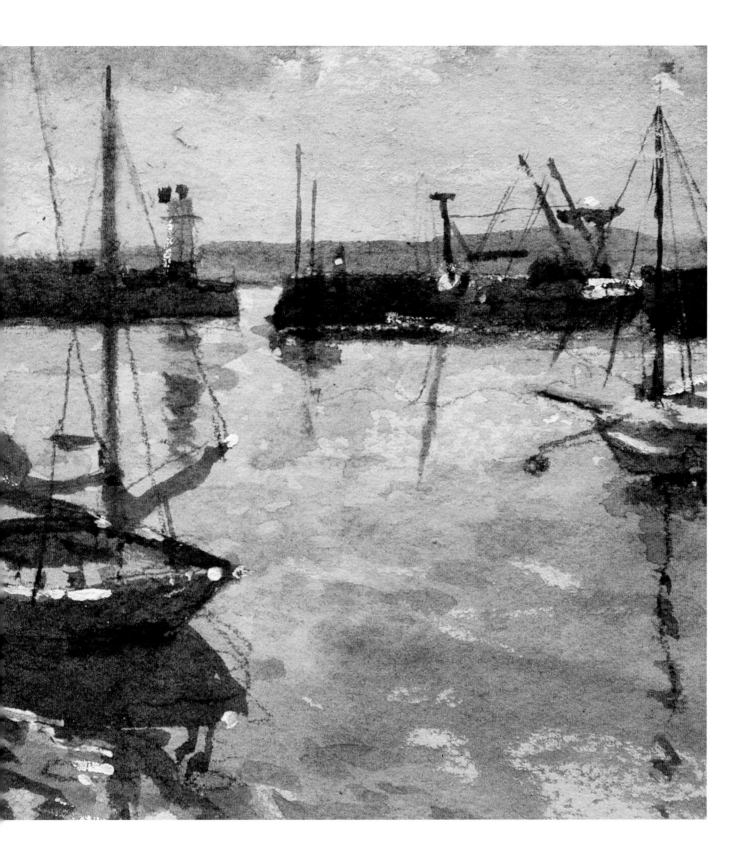

OILS

The greatest advantage of oil painting is its versatility and ease of manipulation. You can achieve an incredible range of effects – from watercolour-like transparent glazes to opaque layers of impasto. In my already-mentioned desire to break down the technical differences between watercolours and oils, I enjoy laying in thin scumbles, interplaying translucent glazes with opaque, buttery-texture paint, scraping off when necessary and sometimes applying final glazes to bring back colours that may have sunk.

PRODUCING SMALL PANELS FOR ALLA PRIMA WORK

My working practice with oils varies according to whether I am working alla prima or in the studio. Either way permanence is a critical consideration and I believe it is important to develop an informed understanding about the correct preparation of the supports you use, and the properties of the paint.

To capture the effects of sunlight when working on the spot I work quickly on small panels, which I prepare myself, usually in early summer. I buy hardboard in about a hundred various sizes from 8 x 10in (20.5 x 25.5cm), up to a maximum of 16 x 20in (40.5 x 51cm) – no larger because you cannot finish a painting *in situ* if your boards are too large (also, larger supports require battening on the reverse side of the hardboard, to prevent warping).

LIGHTBREAKS, SENNEN (c1997)
Oil on canvas, 40 x 48in (101.5 x 122cm)

Painted in the studio from various sources completed on the beach.

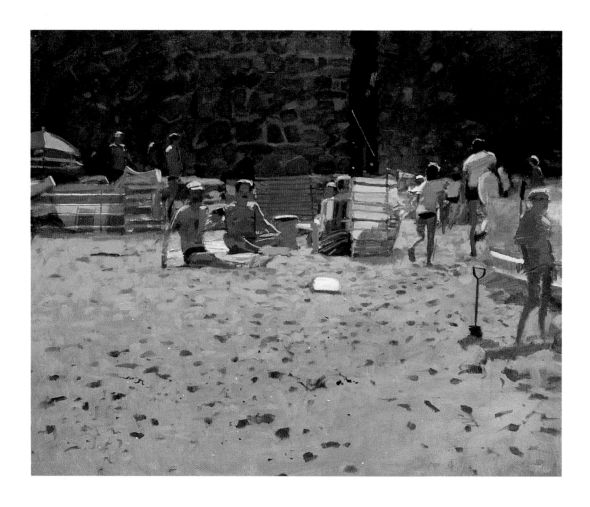

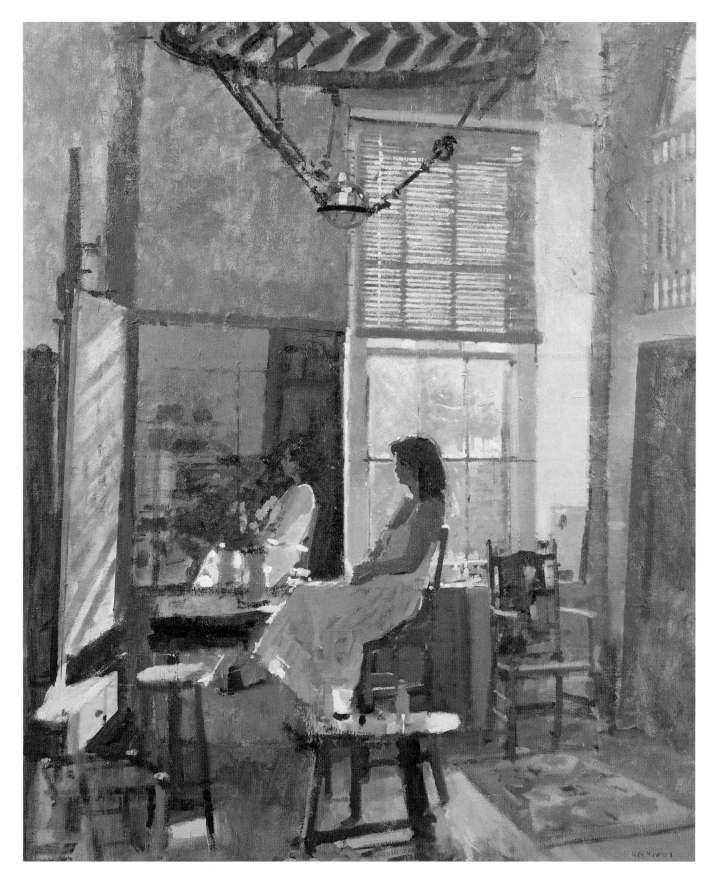

DORA REFLECTION (1997)
Oil on canvas, 48 x 40in (122 x 101.5cm)

*Using thin, turpentine-diluted paint allows the mid-tone ground colour to
show through and become incorporated into a painting.*

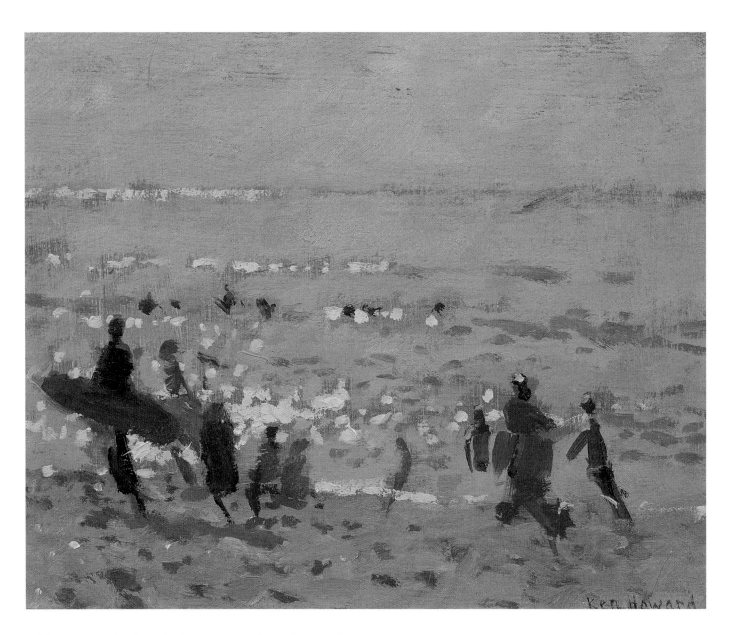

To prepare the boards for painting, I sandpaper the edges and cover each one with a good quality muslin, which is sized on to the boards with rabbit-skin glue (70 grams of rabbit-skin glue to 1 litre of water). Rabbit-skin glue is the traditional size for oil-painting supports as it has good adhesive strength. It comes in the form of granules, which I allow to soak and swell in water overnight in a pan. The next day I gently heat the resulting mixture by placing the pan in a saucepan of water on the cooker until the solution has melted, never allowing the size to boil.

Keeping the glue size lukewarm, I apply a thin coat to the smooth side of the hardboard – rabbit-skin glue is a strong adhesive and should be used thinly, or it will crack – and then lay the muslin, cut to allow an inch

SURFERS (1997)
Oil on board, 8 x 10in (20 x 25.5cm)

A typical alla prima study from which the large studio picture opposite was painted. The painting technique is rapid and direct, the shapes of the figures suggested in broad dabs and touches of paint.

GOING HOME (c1997) *(Right)*
Oil on canvas, 40 x 48in (101.5 x 122cm)

In this larger studio painting I tried to achieve the same spontaneous gestures that I had when working on the spot. Of course I would have loved to have painted this larger canvas on the beach with a large brush, but this would have resulted in too many problems.

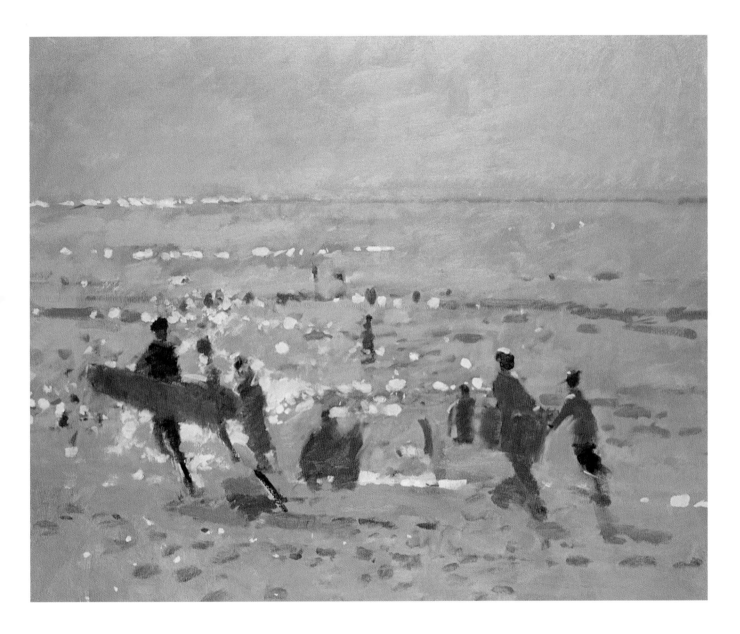

overlap all round on top of the board. Another coat of size is applied to the fabric, smoothing out any creases or air bubbles. The board is then turned over and the overlapping edges of the muslin stuck to the back of the board with size, with the corners neatly folded. The boards are left to dry for twenty-four hours before applying two good quality, matt-white undercoats at twelve-hour intervals, to seal and protect the support and provide a base that will readily accept the paint from the brush.

TONED GROUNDS

A white ground can be inhibiting to work on and it also gives a misleading idea about the tones and colours put down in the early stages of a painting. For example, colours often appear to be darker on a white surface than when surrounded by other colours, which can lead to painting in too light a key. On the other hand there are times when I like to work directly on to a white ground, laying in the painting with thin turpsy colour to 'kill' the white surface to begin with, then 'rubbing out' the lightest areas with a rag. A neutral, mid-toned ground makes it easier to assess tones and colours correctly – it also helps to harmonize a painting, pulling together the colours laid over it.

The colour of the ground depends on the subject. For me it is important that it relates to the palette I am working with at the time – hence I often use a diluted mix of the colours remaining on my palette at the end of a day's painting. Some artists like their ground colour to complement the dominant ones on their palette; Constable often

worked on a burnt sienna ground to complement the greens in his landscape paintings. This is one approach, and in fact I sometimes use a burnt sienna or light red ground – diluted and applied as a thin wash – in order to give a lift to the silvery greys in a painting. But there are no hard-and-fast rules: the choice of coloured ground is a matter of personal preference.

CANVAS

For the larger studio paintings I work on stretched canvases. As a student, and for the first ten years after leaving art college, I used to prepare my own, which is more economical. Now I buy ready-prepared linen canvas, which retains its tautness better than cotton canvas when stretched on the frame. It also has a fine, even grain and responds well to the stroke of the brush.

To eliminate the greasiness of the canvas I apply an additional thin coat of matt-white undercoat, to which I add a colour to create a toned ground; otherwise, once the white ground is dry I may rub a transparent scumble of thinned raw umber or burnt sienna on to the surface.

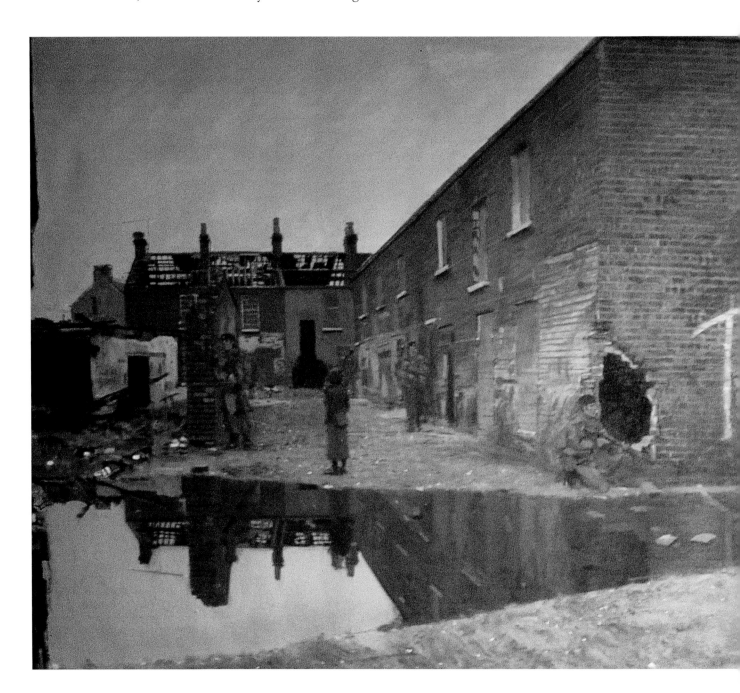

PAINTS, DILUENTS AND MEDIUMS

My oil paints are always artists' quality and from various manufacturers. My choice of colours varies according to whether I am painting alla prima or in the studio, but is always limited, and is explained in the next chapter.

As for diluents (substances used to thin paints to aid their application), I basically agree with Sickert's attitude that you should thin your colour by the vigour with which you apply it, in other words he believed there was no need to use diluents such as turpentine. Often there is enough

oil in commercially produced paint to make the use of turps redundant in any case. On the other hand, I sometimes start a painting using colour thinned with turps in order to cover the entire canvas quickly. An alternative method is to drag undiluted colour across large areas of the canvas with a palette knife.

Today a large range of prepared painting mediums is available, but when I started painting I had to prepare my own. The traditional medium was a slow-drying mixture of refined linseed oil and distilled turpentine, one part oil to at least two parts diluent. I would start a painting using

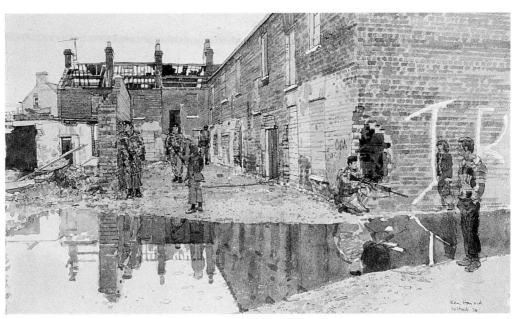

PATROLLING, BELFAST (c1976) *(Above)*
Watercolour, 11¹/₄ x 15¹/₄in (28.5 x 38.5cm)

I was moved by the incredible reflections in the puddles and later used this as a study for the much larger oil painting, shown left.

PATROLLING, BELFAST (c1976) *(Left)*
Oil on canvas, 60 x 72in (152.5 x 183cm)

Note how the oil version of this subject has become much stronger and dramatic in tonal contrasts and how the colour values have changed.

colours thinned with turps, gradually introducing more linseed oil to 'fatten' the medium for the final application of paint. This was important from a technical point of view because it meant that early on in my career I began to enjoy using glazes.

Although you should not be inhibited by 'correctness' or rules, some of the fundamental principles of oil painting, including working 'fat over lean', are essential, sound techniques. If you try and put a thin colour on top of thick paint, for example, the layer below will dry more slowly and contract, causing the hardened, thin layer on top to crack. In addition, I work from thin darks to thicker lights, letting the ground colour act as the half-tone. To establish the placing of the lights I often put these down as well in the early stage to see if they will work, before scraping them off again with a palette knife.

BRUSHES

I use hog-hair flats and filbert brushes – sizes 6, 7 or 8 for small panels; larger sizes and 2in (5cm) housepainter's brushes for bigger canvases. As a general rule I would say always use as large a brush as possible relative to the size of a painting. This prevents the temptation to fiddle, or become distracted by detail. Hog-hair brushes are tough and springy and react well to the textured surface of the canvas – I avoid the modern synthetic types, which do not respond as well to the heavy texture of oil paint.

My preference is for square-ended brush shapes because for me, oil painting is about putting down mosaic-like facets of paint which merge to make a reality when viewed from a distance. I suppose my choice can be explained by my instinctive roots in the Newlyn School, and love of painters like Stanhope Forbes who developed the square-brush technique, emphasizing the effects of light and atmosphere.

DINGHIES AT MARAZION (1997)
Oil on board, 12 x 16in (30.5 x 40.5cm)

The toned ground for this painting was created by thinning the remaining colours on the previous day's palette with turps. This formed a harmonizing base for the colours on top.

Ken Howard

PALETTES

For working alla prima I use the wooden palette (roughly 12 x 15in/31 x 38cm) in my box easel, which also carries brushes, paints, white spirit, jam jar, rags and a ruler. The ruler helps me to establish the horizon line to show the right proportion of sky to ground in the composition before I start the painting. Also, because I have a slight problem with the Verelux lenses in my glasses, which tend to bend the verticals, I always have to establish a true vertical on the canvas to work to.

Recently I have begun to appreciate the advantage of using a disposable palette (made of oil-proof paper) as well, not only for the convenience of being able to tear off the top sheet and throw it away, but also because it helps

HIGH WATER, SUMMER (1996)
Oil on board, 10 x 12in (25.5 x 30.5cm)

I painted several large studio paintings based on this sketch.

to see the lightest tones of colour against the white of the paper, rather than the dark or half-tone of the wooden palette. In the studio I occasionally use one of my prepared white panels as an alternative to the disposable palette, and once the painting session is finished I brush whatever colours are left across the surface of the panel, using plenty of turps, to make a neutral tinted ground.

WORKING ALLA PRIMA

For painting alla prima my working method suits the shortage of time; as I say elsewhere, I usually allow myself a maximum of one and a half hours in front of my subject. I therefore concentrate on getting the palette ready to begin with, mixing four or five large puddles of colour to cover the range of tones from the darkest to the lightest – it is pointless laying out too little colour when you need to work quickly. This allows me to work rapidly, suggesting the main groupings in broad brush strokes, adjusting and pulling together the dark, light and mid-tones as the painting progresses. Degas summed up this basic approach when he said that it is essential initially to establish and express the dominant tone around which the harmony of the painting is organized.

One of the greatest mistakes in oil painting is to try and make the paint go further than it should by thinning it too much with turps. This is one reason why the preparation of the palette is so critical. As a teacher Whistler always looked at a student's palette first: if it was well laid out he knew the painting would be good; if it was a mess he knew the painting wouldn't be worth looking at. Sickert had a similar view. He likened oil painting to cooking: for him the preparation of the 'ingredients' was the important part, the actual painting, the cooking, was easy!

PREPARING FOR THE EVENING RACE (1977)
Oil on board, 10 x 14in (25.5 x 35.5cm)

Painted on the spot, alla prima, with a primary palette. I had to work quickly to distil the essence of the scene.

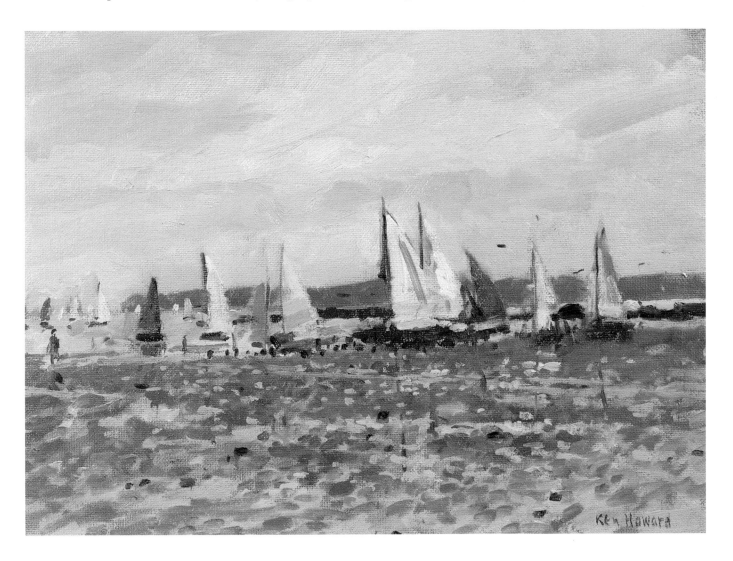

An advantage of working alla prima in one wet – in a single painting session – is that the whole composition comes together fairly quickly in a unity; the painting dries equally across the whole surface of the panel and there are no problems regarding the sinking of the paint film. Sunken patches, characterized by areas of dull, matt paint, are caused by overlaid layers of colour drying out at differ-ent rates, and are more likely to occur if you leave a paint-ing for more than a week and then resume work on it. You can, of course, bring sunken patches back to life by brushing a little retouching varnish over them to restore their true tone and colour value, but it is better from a technical point of view to finish a painting in one wet, which is much easier to achieve on small panels.

My aim in painting alla prima is to capture the essence of the subject in an intuitive way and with a freedom of brushwork that has its roots in the alla prima work of the Impressionists, and their forerunners, Constable and Corot. They introduced a liveliness of approach and a vigorous brushwork that was instrumental in expressing the effects of light on a subject.

This direct method of painting requires a spontaneous and unhesitating approach to capture the first impression; it therefore requires confidence and speed and so it is important to be clear about what you want to express. For this reason, too, I emphasize again the importance of preparing the palette well first, in order to avoid inhibiting the spontaneity of the brushwork.

STUDIO PRACTICE

It is much more difficult to complete a large canvas in one wet; nevertheless I am at a stage in my life when I want to try and recreate on a larger scale the same excitement I feel when painting on small panels on the spot, alla prima. And in fact some of my studio pictures are painted direct, in a manner similar to the alla prima panels, without any preliminary underdrawing.

For the large 48 x 60in (22 x 152.5cm) studio interiors I usually try out the composition on a smaller, 20 x 24in (51 x 61cm), oil painting first and then develop this on the larger scale once I am satisfied that the composition will work. For the larger canvas I usually start with a minimal amount of charcoal drawing to establish the overall arrangement of the picture; alternatively this might be squared up from a preliminary drawing or watercolour study. If you work in this way it is important not to be too precise or tight with the drawing because sometimes a

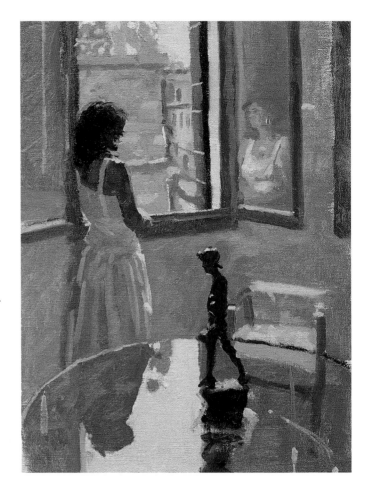

DORA AT DORSO DURO, VENICE (1997)
Oil on canvas, 16 x 12in (40.5 x 30.5cm)

A small-scale oil study for Venice Reflections.

composition that works on a small scale does not transfer to a larger one. For this reason I never decide on the scale of the parts until the painting starts to evolve – I remain open-minded about the adjustments and readjustments that may need to be made throughout its development.

Of course you cannot do this with watercolour, and I believe that it is precisely this ongoing struggle to get the composition right that gives an oil painting an exciting and unique quality. The actual process of painting the picture – which became much more evident in the freedom of brushwork of the Impressionists – is as much a contributory factor in the overall effect as the actual subject of the painting. Indeed, this is the answer I give to the question I am often asked, about why I leave some of my drawing lines in a picture. They are the evidence of my

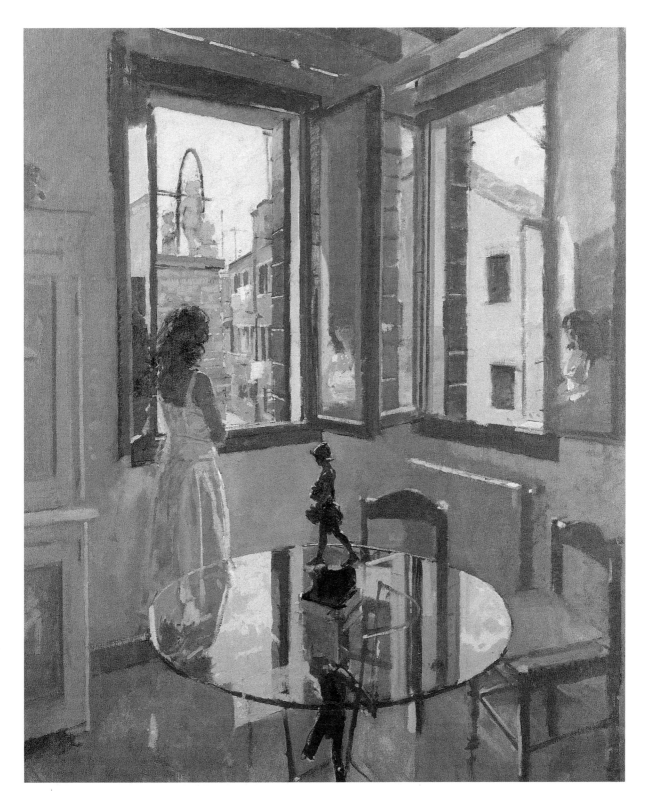

VENICE REFLECTIONS (1997)
Oil on canvas, 48 x 40in (122 x 101.5cm)

*Here I have taken in much more of the room than in the small
study, and made more of the reflections, which were the original
motivation for the painting.*

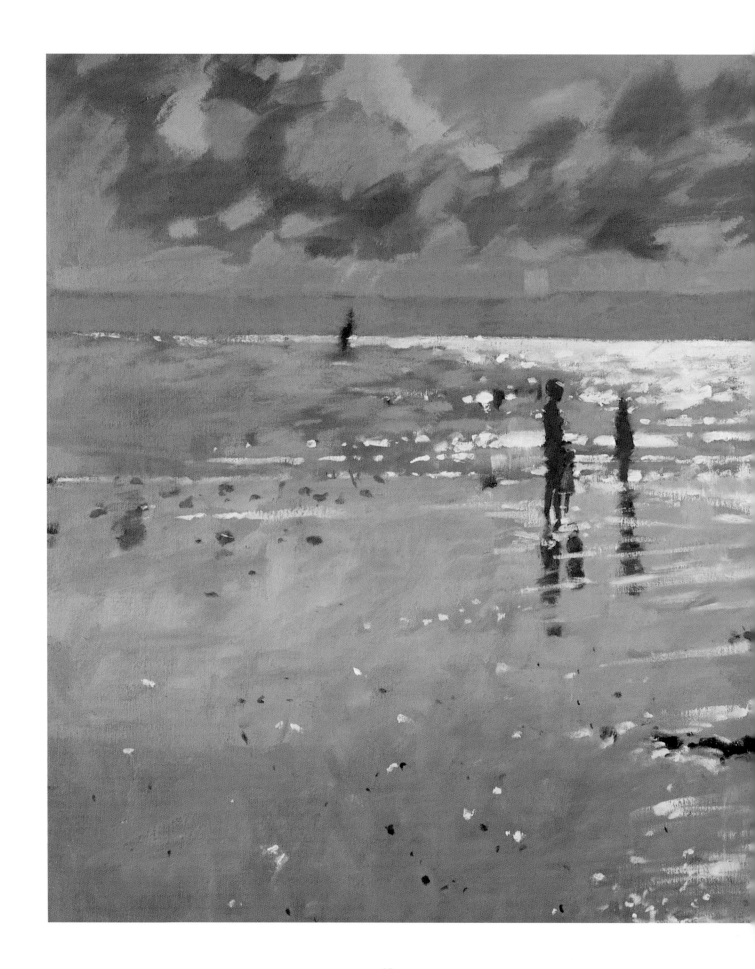

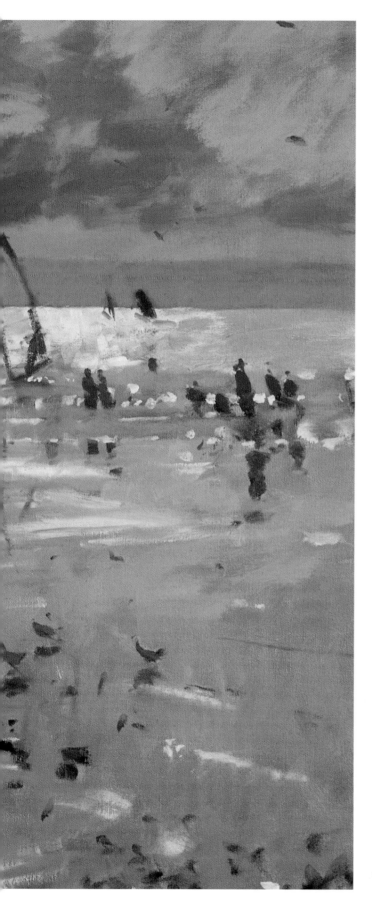

struggle to establish an eye level, or the vertical and horizontal architecture of the composition, and I believe a painting is much more exciting when you can see some of the obvious process behind its making. This also means that the last marks you make should be regarded as the final adjustments to that process, not as a means of 'finishing off' a painting.

REMOVING EXCESS PAINT

Losing and redefining the edges between facets of colour is also part of this process of adjustment, which in the studio pictures includes scraping off impasto areas with a palette knife from time to time. Occasionally I might rub the paint off with turps and start again, or I might remove excess paint by 'tonking' it, ie placing a sheet of absorbent paper, such as newspaper or toilet tissue, over the area, smoothing with the hand and peeling the paper away, lifting the excess paint with it. I probably scrape off paint with a palette knife more than tonking, although both have a similar effect. When working on board, tonking is better because it doesn't lift off quite as much paint; scraping off with a palette knife can only be done successfully on canvas because the texture of the linen prevents all the colour from lifting off.

LONG ROCK, EVENING LIGHT (1997)
Oil on canvas, 40 x 48 in (101.5 x 122cm)

An example of a large studio painting, inspired by an oil study completed alla prima. Although I changed the position of the sail in this composition, i tried to recreate the same excitement i felt in front of the subject, to capture the essence of the scene on a larger scale.

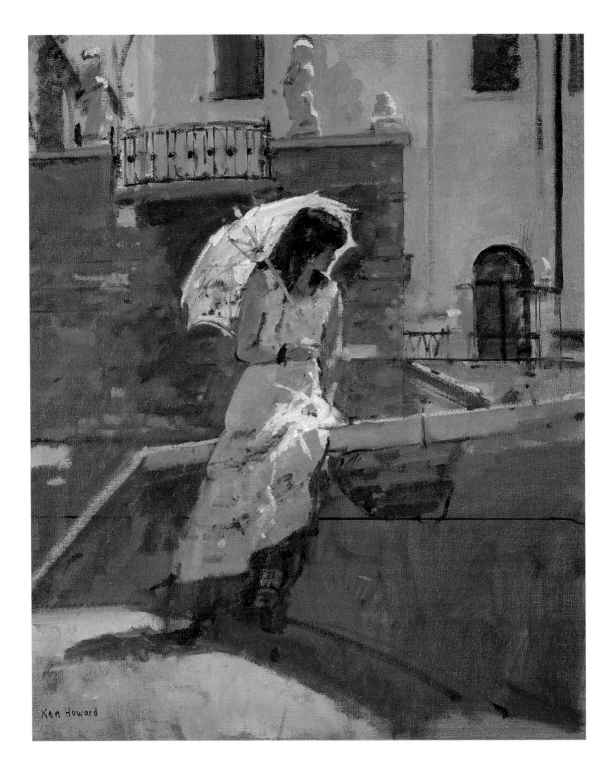

DORA AND THE WHITE PARASOL (1997)

Oil on canvas, 23¹/₂ x 19¹/₂in (59.5 x 49.5cm)

Until recently I avoided painting the figure on a large scale en plein air *for practical reasons. Seeing Dora sitting on this bridge and the effects of the light on her parasol and white dress, however, forced me to overcome my previous hesitation. Ultimately, the expression of your idea – the stimulus for a painting – is paramount and far more important than location or technical difficulties.*

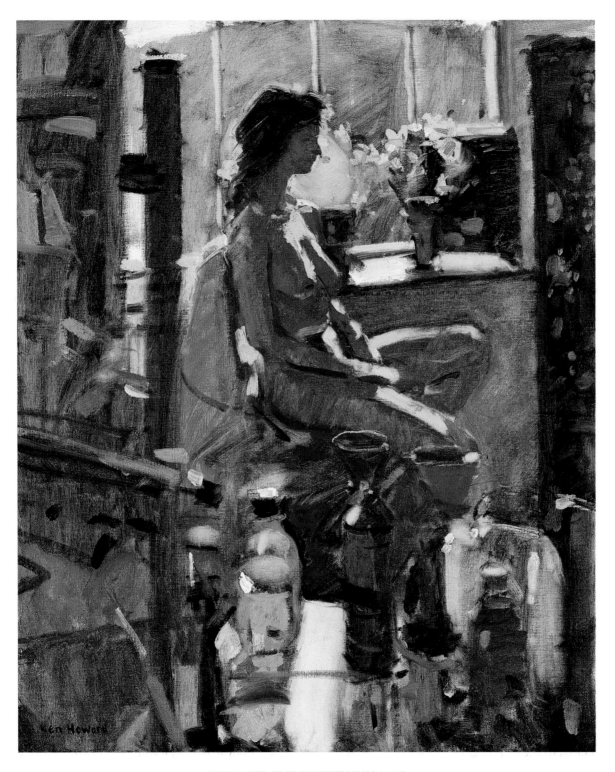

CHARLOTTE AT ST CLEMENT'S HALL (c1985)
Oil on canvas, 20 x 16in (51 x 40.5cm)

I used oil paint almost like watercolour for this painting, scumbling and lightly scrubbing thin veils of colour over dried underlayers. The liveliness of the paint surface is therefore retained and the colours underneath are only partially obscured. The interaction between the semi-transparent layers of colour produces an evocative effect as well as subtle tonal and colour harmonies.

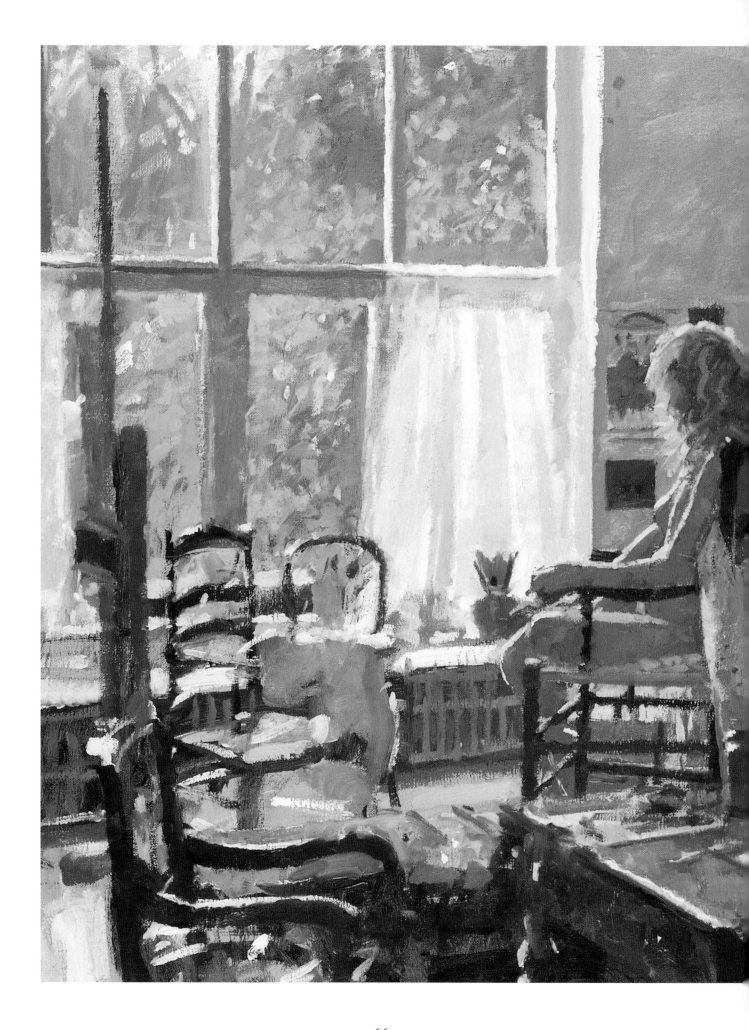

These are useful and sound techniques for paintings worked on over a period of days or weeks. For technical reasons it is better not to leave thick paint on a canvas at the end of a painting session if you want to return to it the next day, or later – it may be touch dry on the surface but it won't be underneath, so when you apply more paint on top either the colour underneath will suck the oil out of the second colour, or worse, the surface will eventually crack as the colours dry at different rates.

Removing superfluous paint is an important part of my studio oil-painting technique because it leaves in place the initial image, and ensures that the painting is touch dry for the next working session. This allows me to continue the painting by applying scumbles and glazes of colour over thin, dry paint, which is an excellent way of modifying colour while retaining the liveliness of the paint surface. The interaction between the two layers can produce shimmering, pearly light effects and subtle harmonies of tone and colour.

I also enjoy the expressive, textural qualities of impasto marks which retain the ridges created by the brush. Painting is all about mark-making and I believe we should celebrate the fact. My oil paintings demonstrate a broad range of paint-handling methods – transparent glazes played against impasto, opaque marks – in my aim to bring my oil and watercolour techniques closer together.

There is no need, I believe, for one to be thought of as an opaque medium and the other as a transparent one.

In the end, of course, technique is only a means to an end, which in my case is the expression of the overall sensation of light which I experience and want to communicate to other people. Once I have achieved this, a picture is finished, regardless of the amount of paint, or lack of it, on my painting surface. My aim eventually is to paint as much as possible, with as little as possible, and as directly as possible.

IN THE STUDIO (1997)
Oil on canvas, 20 x 24in (51 x 61cm)

67

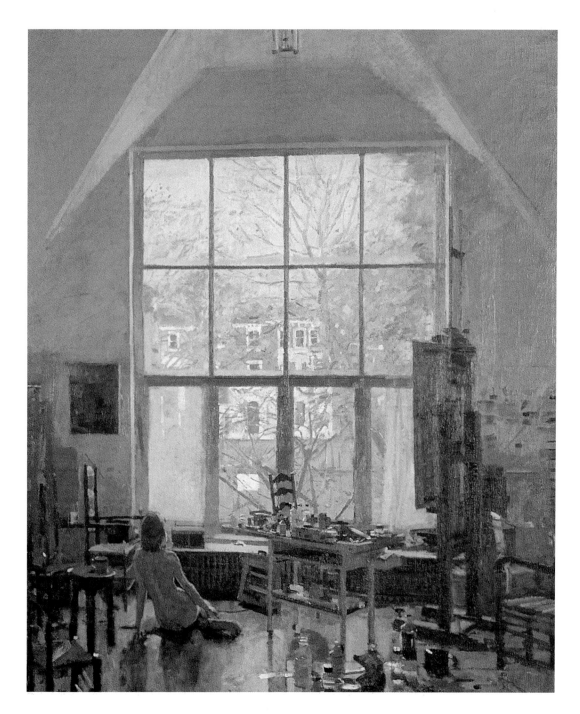

CHRISTA GAA AT ORIEL (1983)
Oil on canvas, 48 x 40in (122 x 101.5cm)

*This painting no longer exists in this form. I was about to send it in to the
Royal Academy Summer Exhibition when a friend whose opinion I
respected criticized it for being over-sentimental. I therefore restated the
figure and worked on the composition for months before arriving at what
became one of my favourite studio interiors. An example of a happy
conclusion to a painful struggle, which would not have been achievable with
watercolour.*

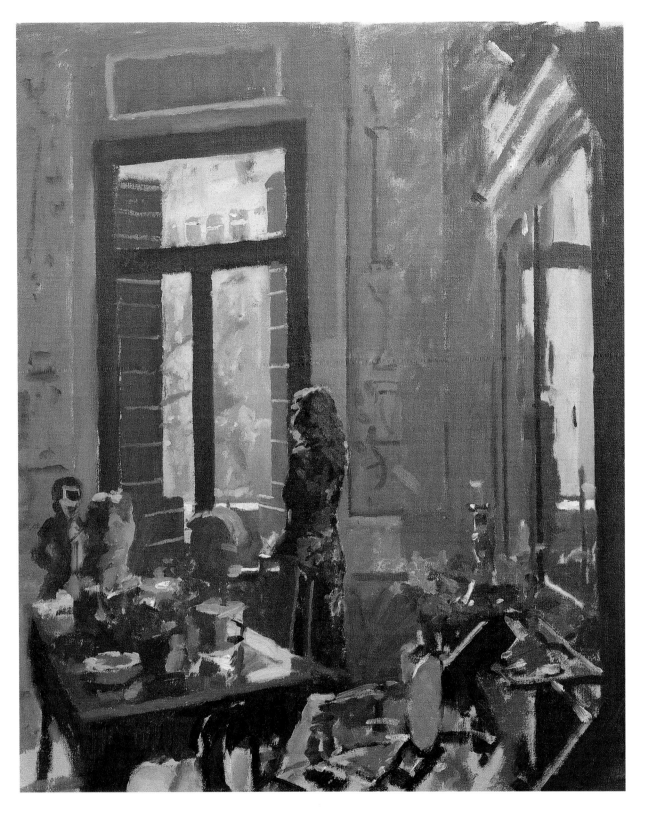

PALAZZO MICHIEL, VENICE, JANUARY (1998)
Oil on canvas, 24 x 20in (61 x 51cm)

The first study of an intended triptych based on this wonderful Venetian interior. I was particularly pleased in this study with the tone/colour relationships between the richly decorated interior walls and the garden seen through the window. I was tempted to state more contrast in the view through the window, but managed to hold the values in relation to those within the interior.

LIGHT, TONE AND COLOUR

Light is my motivation or inspiration for making a painting. The light reflecting on the lagoon in Venice is thrilling; the halo of light around a model's head touches me; light blazing through a beach windbreak is exciting. To capture these effects with any conviction it is necessary to develop an understanding of tone, and the ability to analyse the subject in terms of the lightest, darkest and mid-tones in between.

I have always been a tonal painter, from the earliest silvery grey paintings of railway sidings and the power station at Neasden in London when I could paint only when the light was subdued, to the start of my love affair with strong sunlight and its effects on outdoor and interior subjects. But even with brightly lit subjects, my interest is still in the tonal relationships within the scene, whatever the colour. Tone is the essential tool for expressing the effects of light and it is something that you can learn how to analyse and control.

WHAT IS TONE?

Tone describes the relative darkness or lightness of something. I compare the tones available to us as painters to musical notes, with the dark tones at the bottom of the scale, the light tones as the top notes, and a range of gradated tones in between. In a similar way to a piece of music, too many different tones in a painting leads to visual dissonance, whereas a controlled range of tones in the correct key produces a harmonious composition.

In addition, although the strong darks and lights, or highlights, in a brightly lit subject can have the greatest impact, it is the half-tones in between that will affect the expression of these darks and lights. So it is crucial to scrutinize the subject carefully to distinguish the range of tones, and to separate these from the actual or local colour of things. For example, if a white object is in deep shade, its tone will appear to be much darker than it actually is.

PAINTING CONTRE-JOUR

One of the reasons I like to look at the subject against the light – *contre-jour* – is because this throws much of the subject into partial silhouette, it reduces the amount of colour you can see, and the tonal pattern becomes

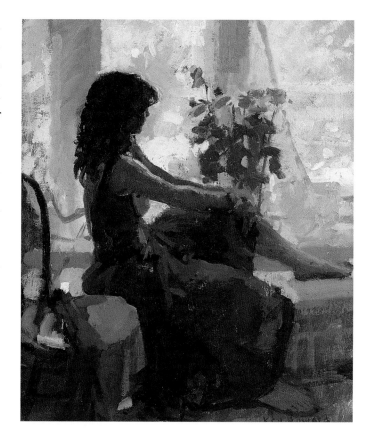

DORA AND THE BLUE DRESS (1996)
Oil on board, 12 x 10in (30.5 x 25.5cm)

The blue of the dress dominates the painting. The variations of blues emphasize the contrast of the dark, almost silhouetted shape of the model against the light of the window. The massing of tones is important; it would have been an easy mistake to paint the light areas in the dress too light, and the darks outside too dark.

strong. As the sun falls in the copper-coloured, late afternoon sky over Sennen beach in Cornwall, for instance, the figures become silhouetted against the sparkle of the sea, the background becomes bathed in a silver-grey light and the whole view is punctuated by the light striking through the windbreaks. But even in these light conditions you still need to recognize and include the half-tones so as to pull the painting together. On Sennen beach the sky is the lightest tone, the objects on the beach the darkest tones, and the beach itself – a large part of my subject – a range of half-tones.

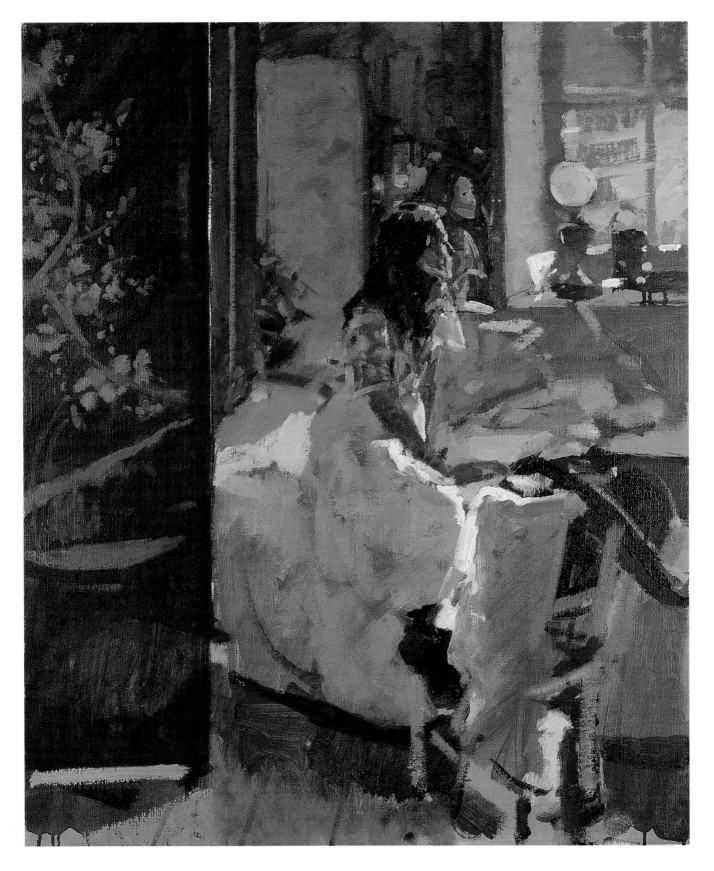

SARAH, SILVER AND BLACK (1996)
Oil on canvas, 24 x 20in (61 x 51cm)

*This picture was painted with an earth palette, plus black. I was
interested at the time in painting white against white, which
highlights all the amazingly subtle variations of grey.*

Another advantage of painting *contre-jour* is that much of the image is implied, and the detail vague. This is important when painting figures on the beach as they become vehicles for the expression of light; details such as faces or feet are a distraction. Rather than being obsessed by the fact that they are human forms, I treat them as shapes, or groups of shapes, to emphasize the effects of light and movement on the beach. Boudin, one of the finest painters of beach scenes, painted wonderful, complicated juxtapositions of groups of figures as simple, silhouetted shapes against the mass of the sky.

Of course, being interested in the effects of light brings its own problems, especially for painters who work from nature. One of the great advantages of painting interiors, especially in my London studio which has north-facing windows, is that the light, and therefore the tonal relationships, remain constant. Outside, on the other hand, both the direction and intensity of the light change

as the sun moves, affecting the range and structure of the tones in the subject. This means that I can work from my subject for about an hour to an hour and a half, at a maximum. It is for this reason that I work quickly, in order to record the subject before the light changes. This feeling of pressure leads to a directness and spontaneity of working that adds to the excitement.

PORTHCURNO BEACH (1996)
Oil on canvas, 12 x 16in (30.5 x 40.5cm)

I consider this to be one of my best beach paintings in terms of colour. I used a primary palette of alizarin crimson, cobalt blue, yellow ochre, cadmium yellow, plus raw umber to harmonize the painting. Ruskin Spear told me that you should always use an earth colour as a binding base colour – even when working with a primary palette. Similarly, it is helpful to introduce a primary colour to an earth palette to prevent it from becoming too bland.

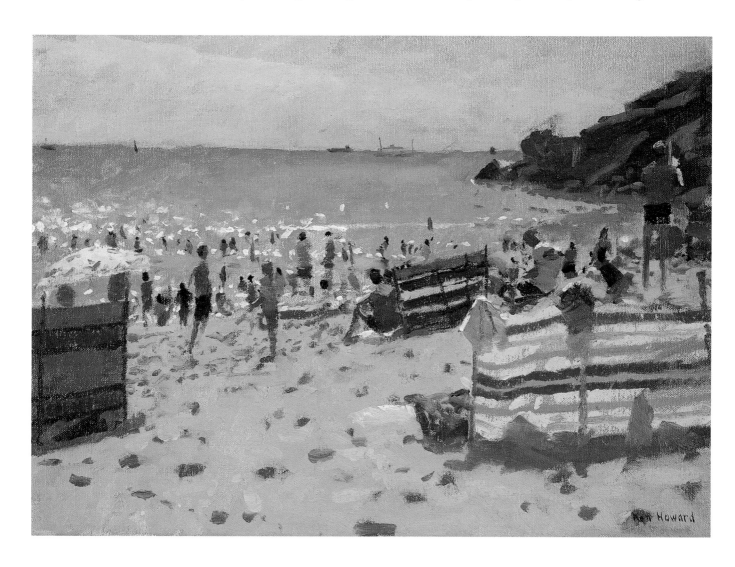

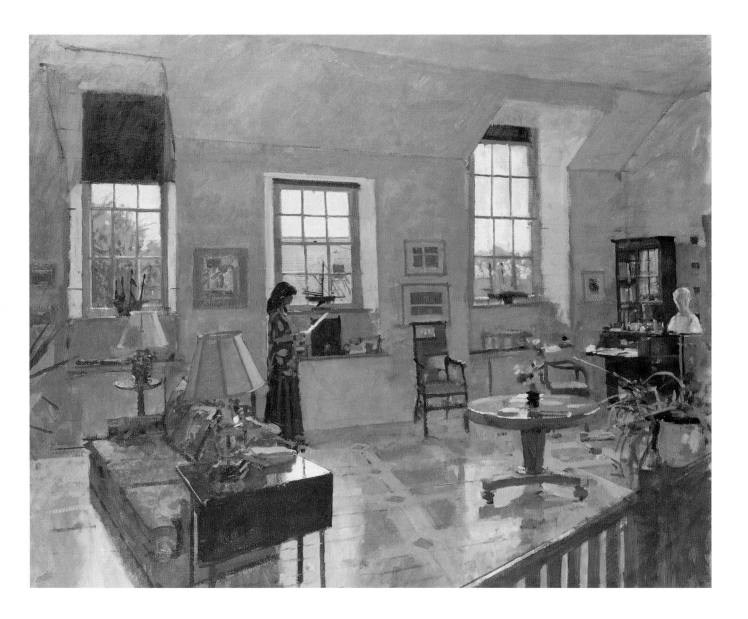

INTERIOR AT ST CLEMENT'S HALL (1997)
Oil on canvas, 40 x 48in (101.5 x 122cm)

With light entering the room through three windows, its dispersion was wonderfully subtle. I especially loved its effect on the colours of the floor.

When I was younger I sometimes made the mistake of painting in oils on too large a scale on the spot, so that each time the light changed I repainted the subject to accommodate the new light effects, resulting in several different compositions, one on top of the other, on one canvas. Now I paint on several different panels, even on days when the light is fairly consistent and even, and discipline myself to the maximum one and a half hours on any one panel. The first summer when I began to work seriously on Sennen beach I took four small panels and worked from the same spot, limiting myself to the maximum time for each panel, which meant that as the day wore on I was able to study the change of light colour values, the changing tide, and also the coming and going of the figures.

TIMES OF DAY AND WEATHER

Some artists prefer to paint either in the morning or in the late afternoon, when the sun is at its strongest, but as I work from first thing in the morning until dusk I am very aware of the changes of light that occur throughout the day. For example, towards midday in Venice the covered Venetian wells situated in the middle of the squares reflect the high sun which beats down from more directly overhead, and burn with a blinding light against the mysterious shadows

behind. In India, on the other hand, the midday sun casts hardly any shadow, what little there is appearing more or less directly below objects.

The weather, too, affects the quality of the light, whatever the time of day, and although bright sunlight and looking at a scene *contre-jour* provide my greatest inspiration, inclement weather conditions can be just as visually stunning and imbue a subject with a different kind of magic. For example, I love to paint the fog in Venice in the early spring or autumn when beautiful atmospheric effects occur on misty mornings.

Patterns of light and dark tone are also intensified when the landscape is covered with snow. The way the white of the snow reflects light is fascinating. Heavy days when the

VENICE TWILIGHT (1997)
Oil on board, 8 x 10in (20.5 x 25.5cm)

To express the brilliance of the light on the water I painted the tone of the sky several shades darker. It is important when judging the tones and colours in a scene to observe the relationships between them. Here I was distracted by the high key of the warm evening sky, but to achieve the effect of sparkling light on the water I had to adjust the other tones relative to these brightest ones. As a tonal painter I find myself constantly adjusting one tonal colour against another.

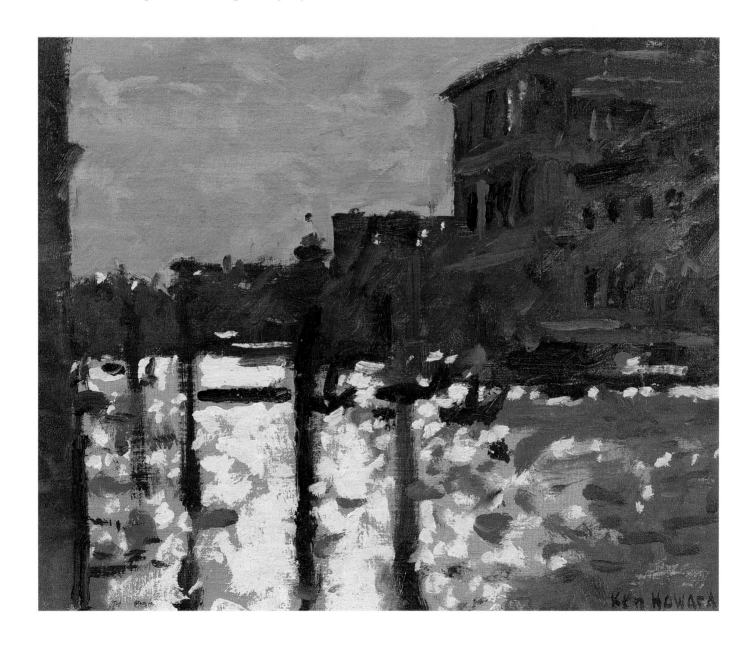

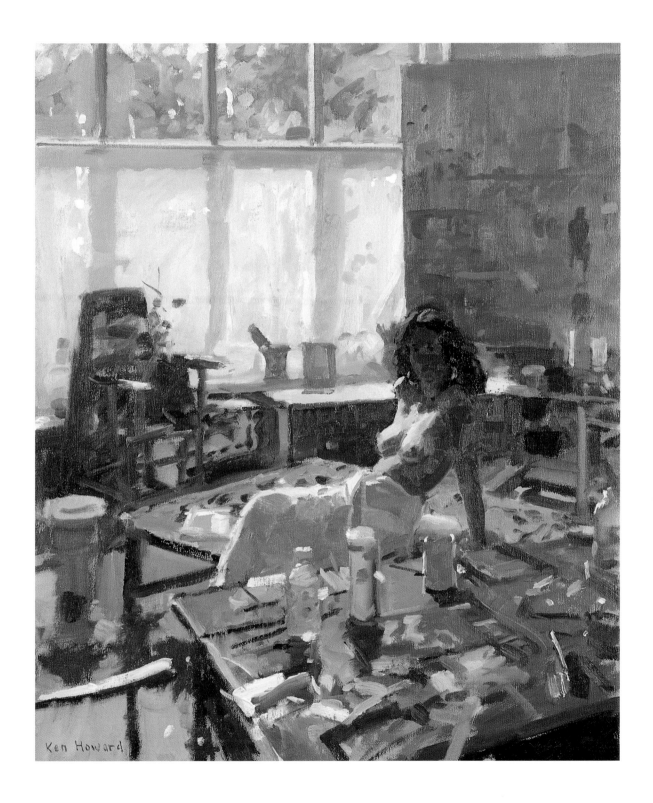

DORA, RED AND GREEN (1997)
Oil on canvas, 24 x 20in (61 x 51cm)

*The neutral colours are enhanced in this painting by the accents of alizarin
crimson and viridian in the foreground, which are repeated in the middle
ground in the kimono and bag on the windowsill. I based all the variations
of grey on these two complementary colours.*

snow is very white and dense, the sky almost yellow ochre and its tone often darker than the snow-covered land, is an appealing reversal of the usual tonal arrangement in a landscape scene. Trees and buildings can be dark and dramatic – rich in grey and earthy colour, and brought into relief by the white of the snow. Sunlit snow scenes have their own magic, too. The snow receives wonderful purply blue shadows, depending on the intensity of the sunlight, which complement the marzipan colours of the landscape where the sun strikes.

TONE AND COLOUR

Painters with an instinct for colour tend to fit their colours into the correct tonal sequence, but if, like me, you are not a natural colourist, you need to be especially conscious of the tone of the particular colour you put down. It is one thing to understand tone in terms of black, white and grey, but when it comes to distinguishing the tone of a colour – its lightness or darkness – we tend to be more receptive to (and therefore confused by) its hue. For example, although cadmium red and Venetian red are the same hue, they are different in tone. This distinction can be critical when you work as I do with a predominantly grey, silver or neutral palette and you want to add a note of red to enliven the picture. If the red is not the correct tone, and is therefore out of sequence with the tonal key of the painting, it will jump forward.

There is a similar problem with green. Many painters have difficulties with their greens in landscape painting because they paint features such as trees in the middle distance the colour they know them to be in high summer, rather than relating the value or tone of their colour to the greens in the foreground. Getting the tone right requires careful observation.

TONAL RELATIONSHIPS

In addition to being aware of the tonal relationships in the subject matter, it is also important to consider the effect of one colour on another when they are placed together in a painting – a dark tone will appear even darker when juxtaposed with a light tone, for example. Sickert numbered the tonal sequence in his working drawings in order to understand the relationships between them, and then used this to prepare the sequence of tones on his palette before starting a painting. The first consideration in preparing a palette is the range of colours: I might choose an earth palette, a primary palette or even a mixture of the

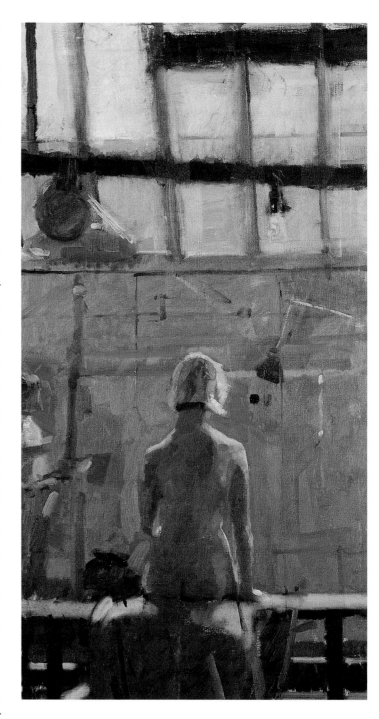

THE LIFE STUDIO, ROYAL ACADEMY SCHOOLS (*c1986*)
Oil on canvas, 48 x 24in (122 x 61cm)

A study in variations of grey with no strong notes of colour anywhere. I made this study whilst teaching in the life room at the Academy schools – I believe that teaching by example is always best.

two, but this will always be with reference to the subject matter. Then I decide on the tonal sequence from, say, the strongest red note to the weakest, from the warmest to the coolest greys, never forgetting that it is the tonal relationship between these colours, rather than their individual hues, that matters most. This gives colours their true value. As Degas said, 'Painting is the art of making Venetian red look like vermilion.'

I use a limited palette for my beach paintings in oils, but this is quite different from the earth palette I select for my studio pictures. As a tonal painter, rather than a natural colourist, I find that a limited palette helps to achieve unity in paintings which could easily become unharmonious as a result of the diversity of the colours typical of summer beach scenes. At the beginning of the summer I restrict myself to cobalt blue, cadmium red and to lemon yellow, with white and raw umber as my anchor colours. As I become more familiar with the subject as the summer progresses I extend my range of colours to include cerulean blue, alizarin crimson, yellow ochre, naples yellow – and occasionally black. In fact the light at the beach in Cornwall is always so intense that I find it difficult to use earth colours.

For my studio paintings I use basic earth colours. In fact, when I started painting in my London studio I limited my palette to black, white, raw umber, yellow ochre and burnt sienna, and was quite amazed by the range of tones and colour effects achievable with such a restricted choice. Burnt sienna, for instance, can appear red when juxtaposed against black and white, which appear blue. Yellow ochre sings when set against a cool grey; raw umber can give a wonderful range of pinky

SARAH ALLONGE (c1992)
Oil on canvas, 24 x 20in (61 x 51cm)

The backlit subject is typical of my visual language; here the model becomes a vehicle for the expression of a harmonious composition in grey and red.

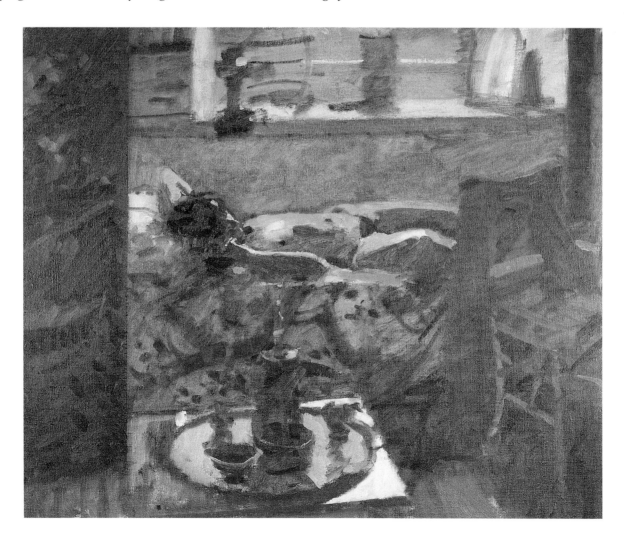

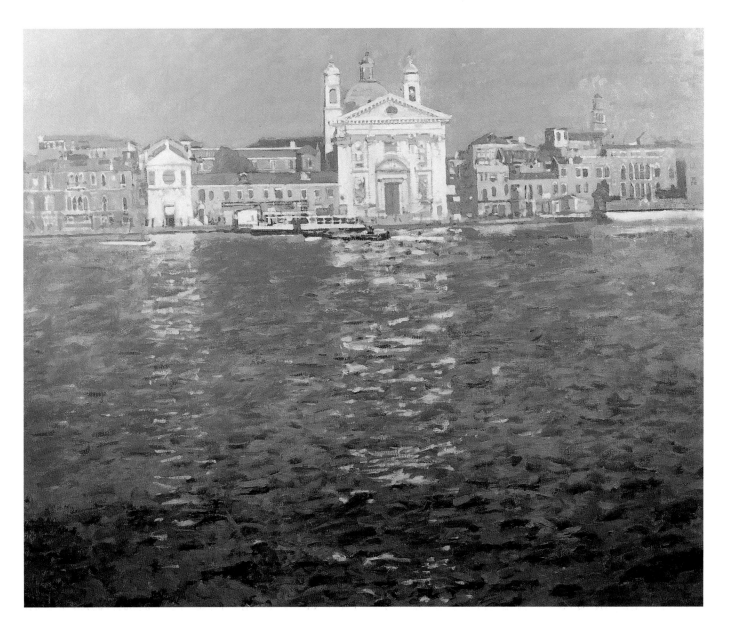

TOWARDS THE ZATTERE (1994)
Oil on canvas, 60 x 72in (152.5 x 183cm)

Painted in London from a series of studies and other large canvases produced during my stay at Geoffrey Humphrey's studio in Venice. This was the view from my room, with which I became very familiar in all light conditions and atmospheres. The inspiration for the picture was firstly the light on the water, and secondly Monet's series of paintings of Venice.

greys. Goya is said to have stated that he could paint flesh with mud if he were allowed to surround this with the right colours.

I later widened my palette to include raw sienna, light red, Mars violet and Naples yellow, and I get enormous enjoyment from playing these colours against each other to express the light effects that inspire me.

White is important in the oil-painter's palette because it is used so often. Zinc white is the most powerful – it is semi-opaque and suitable for tinting and glazing. Titanium white is the whitest and most opaque white and is useful for really singing highlights, but I use it less often than zinc white as it is almost too powerful.

My use of black has varied throughout my career. I have been through periods during which I believed that black

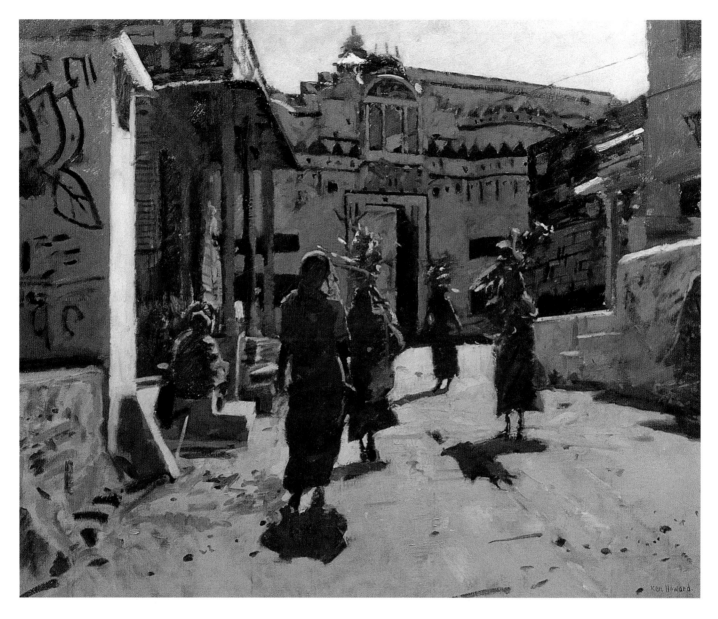

MIDDAY LIGHT, GHANERAO (1994)
Oil on canvas, 40 x 48in (101.5 x 122cm)

Following a trip to Rajasthan I based this painting on a series of watercolours made on the spot, backed up by some photographic references for the figures. I was especially moved by the blaze of light from the unsurfaced road and the light piercing through the women's garments.

had enormous possibilities as a contrast to other colours, and as a means of making greens by mixing it with yellow. At other times I have eliminated it from my palette because it is, after all, a non-colour. I never use premixed greens, although from time to time I use viridian and alizarin crimson to give me my blacks, and as a base to which to add other colours to make a range of greys. But on the whole, green is difficult to fit into a tonal sequence – it can so easily jump out of place.

WARM AND COOL GREYS

At art school we were taught to observe the relative warmth and coolness of colours in nature, and to recognize their tonal sequence, and these are probably the most helpful characteristics to look for. Knowledge of the colour

circle, the primary, secondary and tertiary colours, and how to mix colours is of course important, but when it comes to painting you need to be able to work intuitively, and this comes only with experience.

As a tonal painter I come from a tradition in which colour is considered in terms of earth and neutral colours, such as greys – but these also have endless varieties of warmth or coolness. Vélasquez was a wonderful colourist, yet his palette was relatively neutral: silver grey, earthy, but full of tonal contrast, very rich, very beautiful – never very bright. I am therefore very happy to be regarded as a painter of greys – it is a tradition that I am proud to be associated with. Mixing complementary colours together, plus white in oils, produces rich, neutral greys which can

be moved from warm to cool depending on the amount of cobalt blue or light red included in the mixture. These two colours, or a mixture of ultramarine and burnt sienna or

PIAZZA SAN MARCO AFTER THE RAIN (1997)
Oil on canvas, 60 x 72in (152.5 x 183cm)

My love affair with Piazza San Marco in Venice has lasted for many years and I still feel a surge of excitement whenever I return to it. Over the years my perception of it has changed and I now love it most on rainy, misty winter days when the whole subject is bathed in a beautiful, soft, atmospheric light. I could probably paint this subject for the rest of my life and never tire of it.

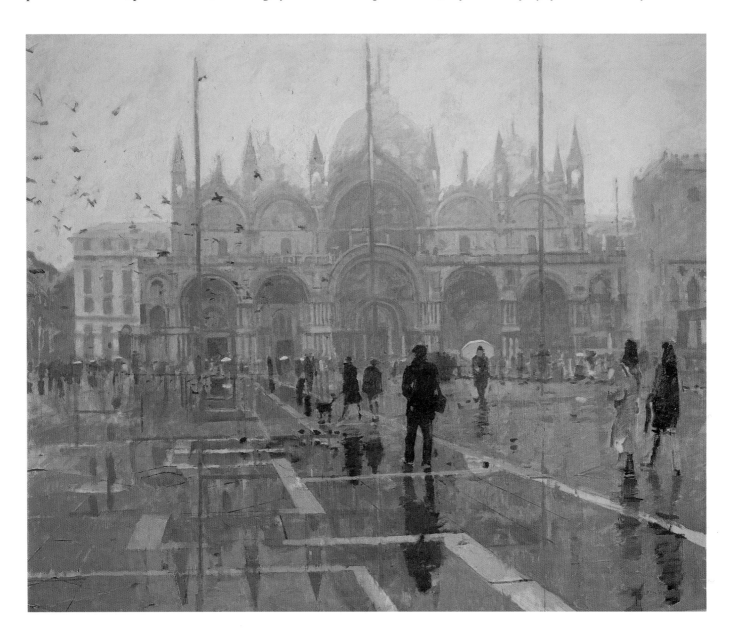

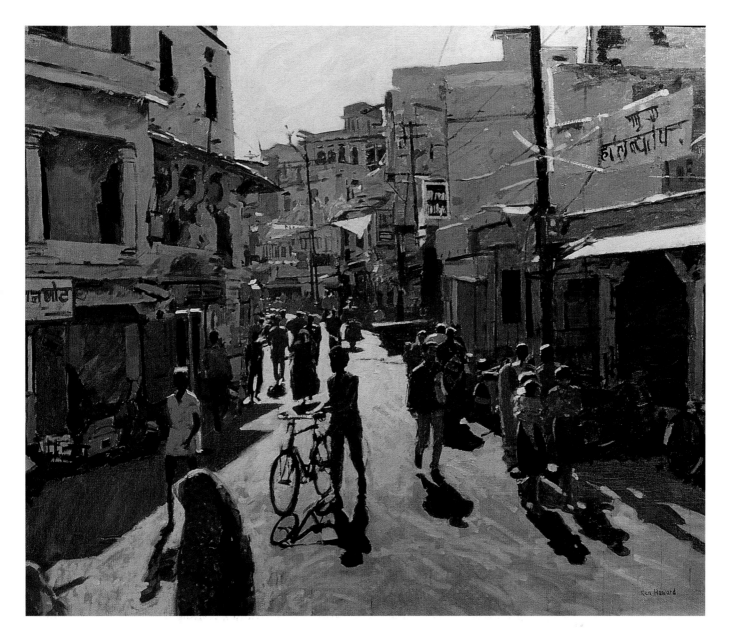

STREET SCENE IN UDAIPUR (1993)
Oil on canvas, 40 x 48in (101.5 x 122cm)

Painted just after midday, the strong light bounced straight off the road and the shadows cast appeared more or less directly below the figures.

Prussian blue and burnt umber, make wonderful greys. Black and white produce a less lively grey, but can be used as a base and colours added like burnt sienna or raw sienna, which impart a very different nature to the mix.

For me grey – from the darkest to the lightest, the warmest to the coolest – is the most beautiful colour, and the painters whose work I love tend predominantly to be masters of colourful greys. As I want to achieve harmony in my compositions it is wonderful to employ the subtle variations of grey to pull the painting together. It also means that when you do add a note of bright colour it will be accentuated by the greys so that it truly sings.

Chapter Five

COMPOSITION

Cézanne described composition as the art of 'arranging in a decorative manner the elements at the painter's disposal'. But for me it's not about decorative pattern-making; good composition is more to do with the fitting together of the parts of the subject so that each individual part is right within itself; each part is right in its relationship to the part next to it, and each part to the whole, so that overall, it expresses the artist's excitement about the subject. This could also apply to music: each musical note must relate to the one next to it and each phrase must relate to the whole movement.

Composition is certainly about analysing the subject in terms of how the objects relate to each other in three-dimensional space, but it also concerns pulling together the painting on your flat surface as a series of shapes, tones and colours that, as a whole, make sense of the subject. As Maurice Denis explained, remember that a picture – before being a horse, a nude, or some sort of anecdote – is essentially a flat surface covered with colours assembled in a certain order.

LET NATURE DICTATE

As a figurative painter, when you are excited by a landscape view, a figure in an interior, the play of light on water, you are in fact moved by the visual effect of the arrangement of the abstract elements in the scene, such as line, tone and colour relationships, and I believe you should remain faithful to your initial sensation. This personal element makes a painting memorable, and it means that I would always move my viewpoint if I were unhappy with, say, the position of a windbreak in a beach scene, rather than manipulate its placement in my painting.

SARAH IN THE MORNING LIGHT (c1989)
Oil on canvas, 40 x 48in (101.5 x 122cm)

Compositionally this may be too cluttered, with few areas for the eye to rest. However, the eye is led on a journey within the picture from the objects on the table, to Sarah in the middle distance, then out through the window. This painting also uses repetition as a linking element; note the rectangular shape of the canvas in the painting on the easel in the picture, and on the windowsill.

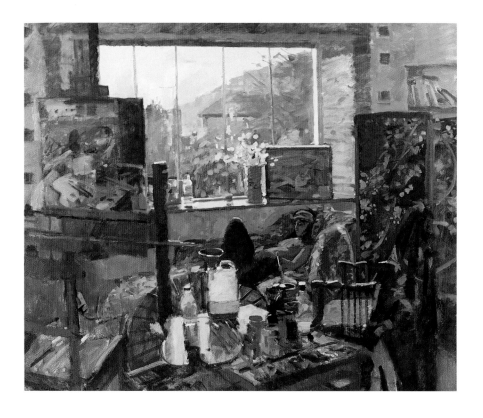

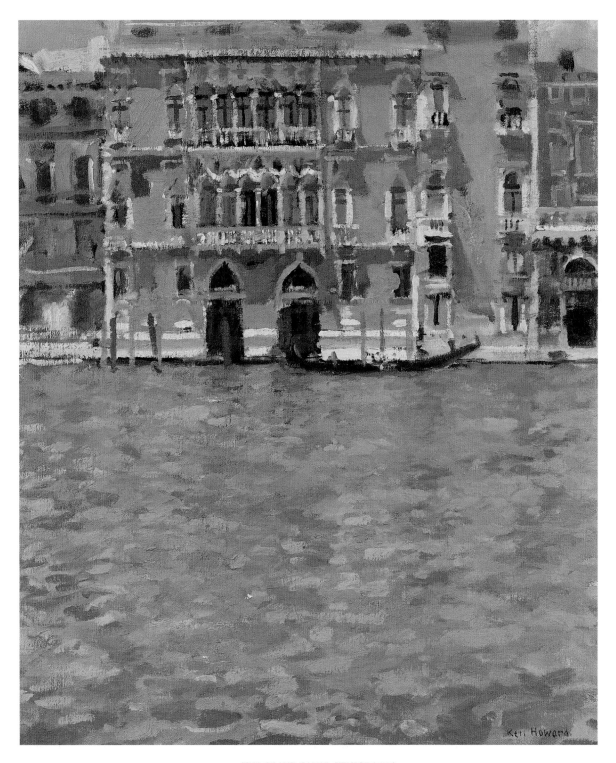

THE GRAND CANAL, VENICE (1997)
Oil on canvas, 20 x 24in (51 x 61cm)

*This composition breaks many of the rules: it is based on a roughly equal
horizontal division of the canvas, but as each half is so different this
doesn't matter. Note, too, how the background colours of the buildings
are warm, yet they recede, while the foreground blues of the water
advance – another flouting of the traditional rules of spatial
organization within a composition.*

Everything in nature is interdependent, just as the elements in a painting are dependent on each other. If you work from nature, I believe you should respect her mysteries. If you are uncomfortable about the view you have chosen to paint because one or more of the features do not accord with your idea about the composition you want to achieve in order to express your feelings about the subject, then you should alter your position until you are satisfied.

Abstract painters, on the other hand, are masters of everything they do: they can arrange their compositions with reference only to their own ideas about the shapes and colours to juxtapose, and how. They are free to do what they like. Artists who paint from the landscape or the figure, however, must be true to their subject and allow *it* to dictate the compositional arrangement of the elements in the painting.

CHOOSING THE VIEWPOINT

Composition starts as soon as you choose the place from which you are going to work. My first consideration is naturalness and reality. For me, pictures should be found, not invented. If you add things you haven't experienced the composition will look contrived. Nature provides endless variety so there is no need to embellish or fabricate. A good basic rule is to omit, but never add.

DORA ON THE GIUDECCA (c1995)
Oil on canvas, 40 x 48in (101.5 x 122cm)

I adopted this viewpoint instinctively. Dora is positioned on an intersecting vertical and horizontal in the painting. The eye is led from foreground to middle distance within the interior via the chairs and through the windows to the recessionary landscape space outside.

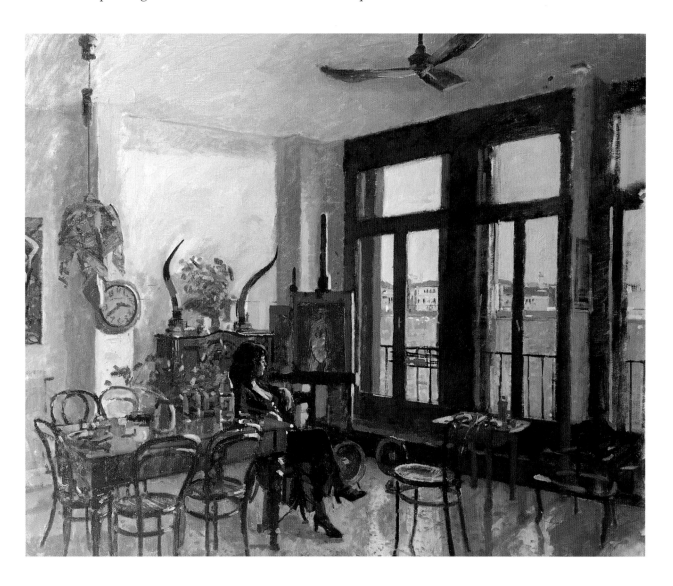

I used to carry a viewfinder to help isolate parts of the scene from the overall view. This can help you to study the whole area within the frame and judge the balance of shapes, tones and colour – you can also consider angles and perspective in relation to its rectangle. Now I sometimes use my forefinger and thumb. I also often look at the scene in a small hand mirror because this helps me to see the arrangement of the parts with a fresh eye.

LEADING THE EYE

One of the aspects I love most about composition is the opportunity to guide people on a visual journey through the picture, which I see as similar to a piece of music taking the listener on an audible journey. You can achieve this in painting in realistic ways, for example by leading the eye into landscape via directional lines which occur within the landscape; or by the rhythm of the different elements leading the eye from one to another within the painting.

Focal points are critical. The worst pictures for me are those in which there is complete visual chaos and the eye is led to no particular point. Figurative pictures should have an area to which the eye is drawn, so it is important when selecting your viewpoint to decide what in the subject you want to emphasize, what will be your focal point. When a human figure is included in a composition, for

NIKI, WINTER LIGHT (1995)
Oil on canvas, 72 x 60in (183 x 152.5cm)

I wanted the composition to be 'tough' and therefore based it on a vertical/horizontal grid, full of tension, and asked the model to stand very straight and tall in the middle of the podium in the centre of the studio. The cold winter landscape added to the toughness of the picture and movement was kept to a minimum.

example, the eye is invariably drawn to it, even if it is only a small part of the overall picture.

In taking the eye on its visual journey it is also important to have open and uncomplicated areas where the eye can relax. Active, cluttered areas which attract the eye need quieter shapes as a counterbalance. Detail and simplicity go hand in hand; if a composition consists only of lots of detail, it becomes fussy and difficult to look at; if it is a simple arrangement of large uncluttered areas it will be uninteresting to the eye. In my studio pictures, I always adopt a viewpoint which facilitates the inclusion of areas of great complexity and relative simplicity. I like to use the vault of the room, the ceiling and simple walls to offset the general clutter and jumble of the studio. The various parts should not impact the viewer with the same intensity throughout the composition – it doesn't happen in nature and nor should it in paintings.

MOUSEHOLE, SEPTEMBER AFTERNOON (1997)
Oil on canvas, 12 x 16in (30.5 x 40.5cm)

The eyeline is more or less level with the upper third of the canvas and the eye is led into the painting by the directional lines of the boats.

SPATIAL ORGANIZATION

A sense of receding space is, of course, just as important to a figurative painter as the 'pattern' of shapes, tones and colours that make up the two-dimensional picture surface. The spatial organization of the composition is dependent on choosing the right viewpoint so that the elements within the scene encourage the eye to move from foreground to background. This can be dictated by a variety of factors within the view, such as the scale of the foreground objects in relation to the size of features

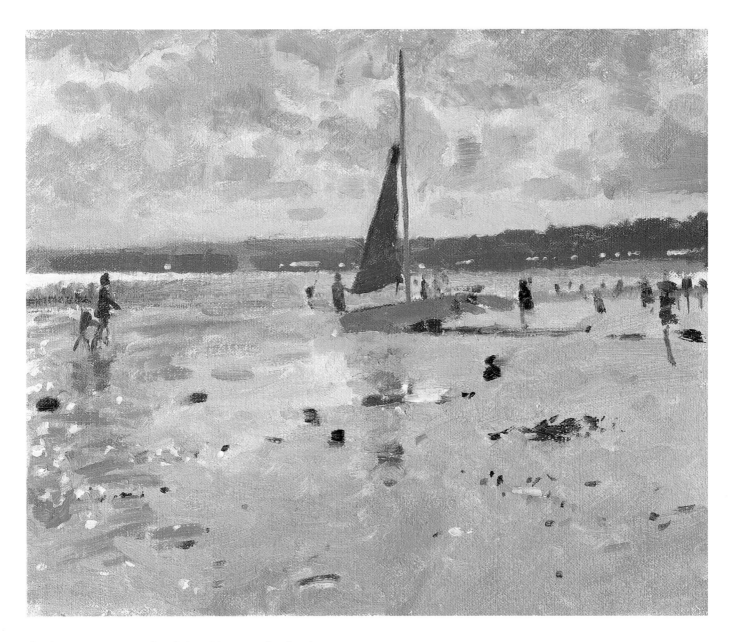

THE BLUE SAIL, MARAZION (1997)
Oil on board, 10 x 12in (25.5 x 30.5cm)

The composition is divided into one-third sky, two-thirds beach and the upright of the sail – the main focal point – is very close to a vertical golden section.

further away, especially if the object is of a familiar size, for example the human figure. A key consideration in compositions that include the figure is the relationship of the scale of the figure to the whole. A common fault is to make it too prominent in scale. Of course, this is something you must learn to judge with experience, but a general guideline is not to allow the main figure to be more than half the total height of the picture.

One of the most exciting compositional devices for achieving recessional space in interior scenes is that of looking through windows to spaces beyond. In these cases I decide what is most important and rarely paint the outside landscape with the same intensity as the interior. Either the interior should be kept broad and simple so

that the eye is attracted to the scene outside the window, or the outside must be simplified to focus attention on the room itself.

Linear perspective – horizontal lines receding into the distance and converging at a vanishing point on the horizon – is also a way of guiding the spectator into the picture. Perspective is, of course, the great spacemaker. Atmospheric perspective, in which colours become cooler

in the distance and warm ones appear to come forward, is another traditional way of defining space in pictorial terms. On the other hand, I don't believe in relying on safe and predictable theories. I have painted pictures in which warm colours recede and cooler ones advance. Boudin could paint a landscape in which a black spot rested in the middle distance of a painting, though the rules say that it should jump forward. I don't want to be told that blue recedes; I want to discover for myself if a particular blue will recede or another blue advance. It depends on the intensity of the blue and its hue in relation to the colour next to it. As Cézanne once said: 'When I start thinking, everything's lost.' I strongly believe that you should learn about theories and formulae and then discard them.

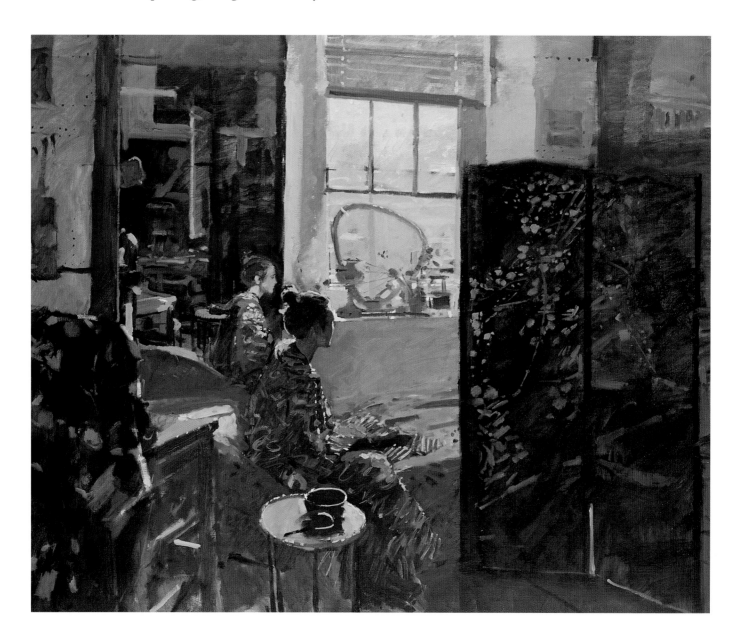

BLUE AND GOLD KIMONO (c1991)
Oil on canvas, 40 x 48in (101.5 x 122cm)

Although the figure and the fan in the window provide rhythm within the painting, they nevertheless act as a counterbalance to the strong vertical/horizontal structure of the picture. The blue and gold in the kimono are repeated throughout the composition, and accents of red enliven the harmonious colour theme.

VISUAL TENSION

My work is largely composed or arranged around vertical and horizontal lines and divisions – and the visual tension between them is most important to me. This vertical/horizontal division of the picture surface is typical of my early railway paintings, and it continues throughout my work. For me the vertical and horizontal epitomize the essential characteristics of nature: the horizon line in a landscape and the upward growth of natural forms. In addition the verticals and horizontals in a painting repeat the parameters of its defining edges, which makes the composition more harmonious and satisfying.

COMPOSITIONAL PITFALLS

There are all kinds of pitfalls to avoid regarding composition and an awareness of these should become an instinctive part of the process of selecting the view from which you are going to paint. For example, the division of a landscape painting into two equal horizontal areas of sky and land can be incredibly boring to look at – which is not to say that it cannot be done successfully. Degas, after all, is the perfect example of a painter who broke all the rules about composition, and yet he was one of the greatest composers of all time. He chopped figures in half and depicted them walking out of pictures, although he would always have another figure leading your eye back.

A pitfall to avoid when composing the arrangement and distribution of tones is the accentuation of the lights and darks at the expense of the half-tones, which makes a composition look unresolved – you need to include the half tones to pull the composition together. As I am interested in light, the tonal composition is crucial.

Colour can be considered in a similar way. A good analogy is the composition of a piece of music in a basic key. In painting your key palette might be cobalt blue, light red and yellow ochre; you might then bring in additional colours to describe the local colours in the scene. But essentially the composition of a painting is held together by its underlying colour harmony – its basic colour key, which should always be chosen with reference to the subject.

The pitfalls described in this chapter should provide a useful set of guidelines towards improving the composition of your paintings. Remember, however, that these are only guidelines; good composition is ultimately a matter of instinct, observation and intuition – plus, of course, experience.

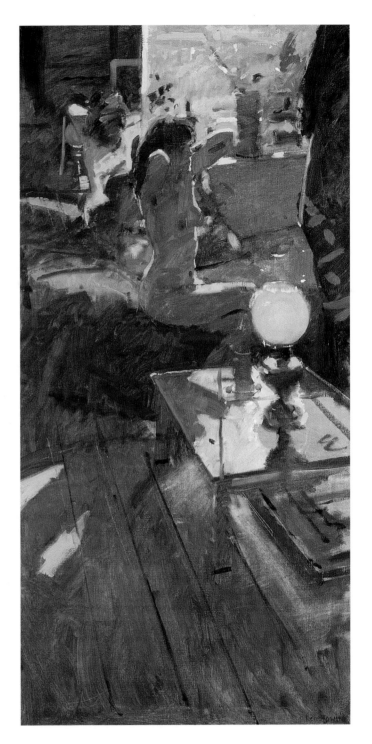

LIZZY AT ST CLEMENT'S HALL (1991)
Oil on canvas, 48 x 24in (122 x 61cm)

It would have been easy to have moved either the lamp in the foreground, the plants or the model to see the reflections that inspired this, but instead I moved my position to discover the arrangement which excited me most powerfully. If you move yourself you are more likely to arrive at original compositions.

OUTDOOR THEMES
AND INSPIRATIONS

I have never regarded myself as a landscape painter in the purest sense, which I believe demands a feeling for the poetry in a view. Instead, I started painting outdoor subjects in the places I knew best – the railway sidings at Neasden and Cricklewood – inspired by the particular light, as well as the strong verticals and horizontals in the scene, and although I have travelled and painted in many different places throughout my career, my choices of subject have always been ideal vehicles for the expression of light.

EARLY RAILWAY SUBJECTS

I have always believed that you should paint the things that awaken an emotional response in you and this does not have to be the picturesque. There is beauty and drama even in industrial settings, and light can transform the most mundane view.

NEASDEN SIDINGS (1954)
Oil on canvas, 12 x 16in (30.5 x 40.5cm)

I painted this subject while on leave from National Service. It contains all the elements that have continued to interest me since: a bias towards earth colours; the definition of space through tone; atmosphere and the effects of light; a strong vertical/horizontal composition. Although my subject matter and colour developed after this, my basic language is encapsulated here. I am a strong believer in the idea that an artist's development is all about gradually refining a personal language.

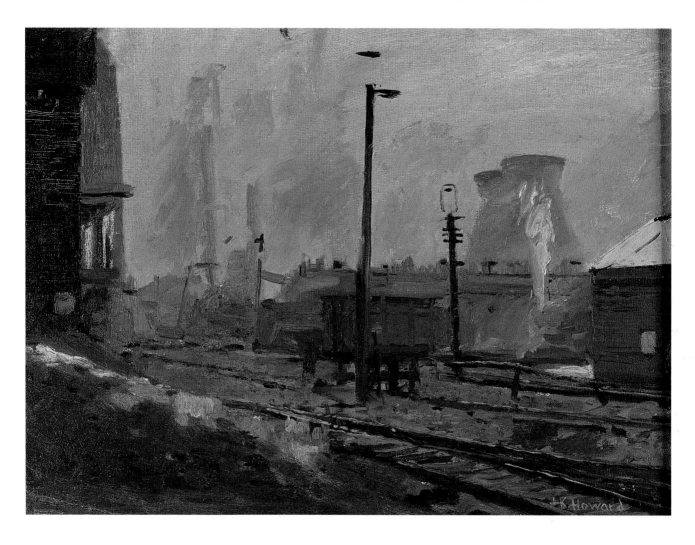

In the 1950s I was fascinated by the vertical and horizontal structures and shapes of the railway sidings near my parents' house in north London. The drama of the pillars of steam from the locomotives added to the excitement and I loved to paint the bulky, closely toned shapes and emissions of steam silhouetted against the sky. Part of the excitement in industrial scenes such as railway sidings is the ever-changing activity and movement which means that you must concentrate fully, work quickly, and give your absolute commitment to the subject. I was probably influenced at the time by Monet's paintings of Gare St Lazare, and the Impressionists' interest in capturing moments of action and light – both consistent inspirations throughout my painting life.

As one of the key aspects about painting, for me, is that it should help to open other people's eyes to the beauty in even the humblest scene, I was delighted when one of the railway workers stopped one day to watch me paint and commented that he had never realized before that the railway yard was so beautiful.

URBAN LANDSCAPES

One of the reasons I love the urban landscape is that it contains plenty of inspiration for the artist who has an interest in the shapes, tones and colours of confined spaces, and the evidence of human presence and activity. These things excite me far more than the vastness of nature – I have never been inspired to paint a panoramic view of the countryside.

ENTRANCE TO THE CREGGAN (1973)
Oil on canvas, 10 x 14in (25.5 x 35.5cm)

I have always been interested in silhouetted shapes against the light and even here, on a dull day in Londonderry, the emphasis is on the drama of the silhouetted buildings against the sky. This helps to emphasize the bleak atmosphere of one of the most difficult areas of Londonderry at the time. These gloomy, earlier paintings, whose atmosphere reflects the problems I was experiencing in my personal life, contrast with later, more optimistic compositions.

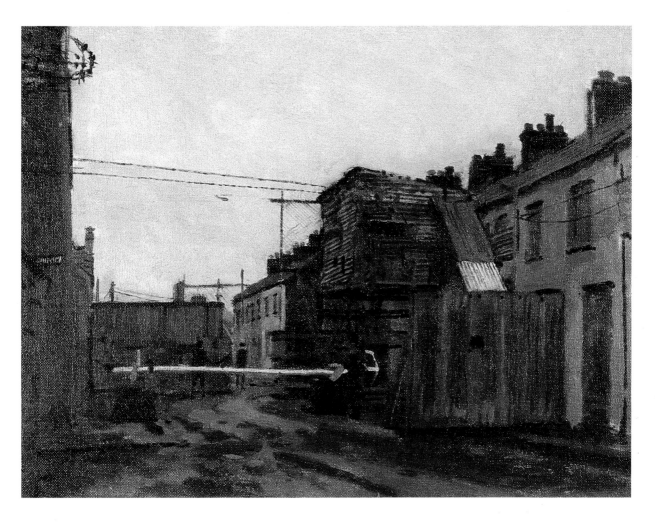

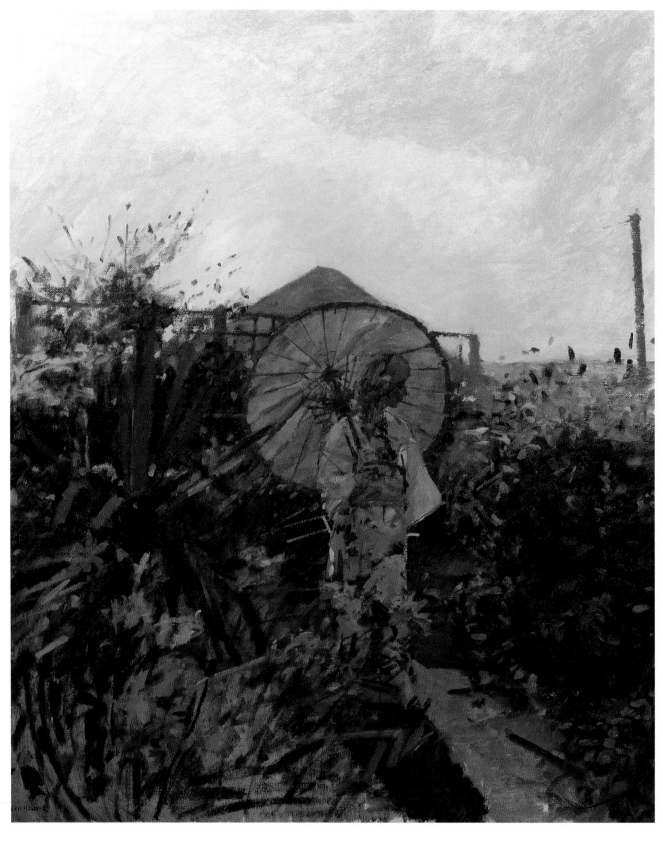

THE RED PARASOL (c1990)
Oil on canvas, 48 x 40in (122 x 101.5cm)

*Painted in my garden in Mousehole, this is an extension of my studio
kimono series, but here the light effect is heightened as a result of the outdoor
setting. I would love to have the courage of the Newlyn painters and paint
my models in outdoor settings more often.*

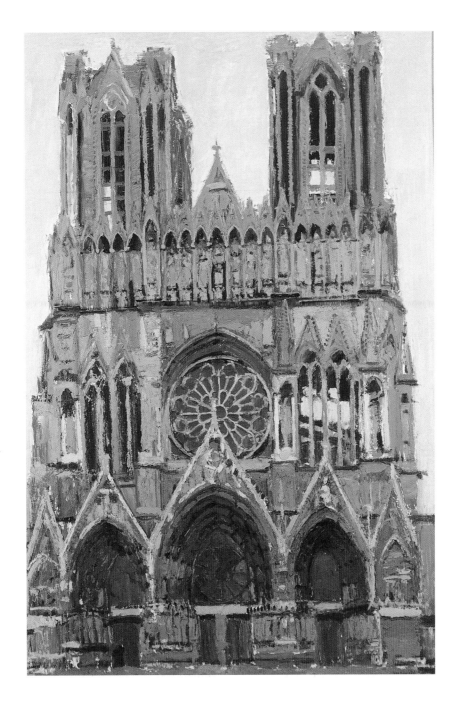

ROUEN CATHEDRAL (*c*1965/66)

Oil on canvas, 38 x 36in (96.5 x 91.5cm)

For a period of around five to six years in the 1960s I became fascinated by architectural subjects, churches, and the façades of buildings and cathedrals such as Westminster Abbey. In these pictures, in which I became obsessed by the tactile nature of the buildings' walls, I came closest to Denis's definition of painting as being first of all an arrangement of shapes and colours on a flat surface. But after I had experimented with mixing sand with my paint, inspired by Maurice Utrillo's example, I started to feel that my work was becoming too mannered and returned to my interest in the actual spaces of urban subjects and their atmosphere, the movements within them, and light.

For around four years in the 1960s I was influenced by Utrillo's early textured paintings and I mixed sand with my colours, which I applied with a palette knife, to emphasize the textural quality of the paint. This absorbed me until in the end I felt that my approach had become too mannered, the paint too thick, and I was moving closer to more abstract concerns, which I didn't want to do.

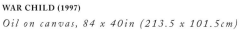

WAR CHILD (1997)
Oil on canvas, 84 x 40in (213.5 x 101.5cm)

During my 1996 visit to Dubrovnik to paint the old city in preparation for the exhibition planned to raise money to restore the historical monuments of Croatia, I was invited to Mostar. Here I was shocked to discover devastation similar to that which

Lebanon had suffered in the late 1970s. When I returned a second time to the city I painted this picture, which represents my feelings about the destroyed lives of innocent bystanders to these dreadful conflicts.

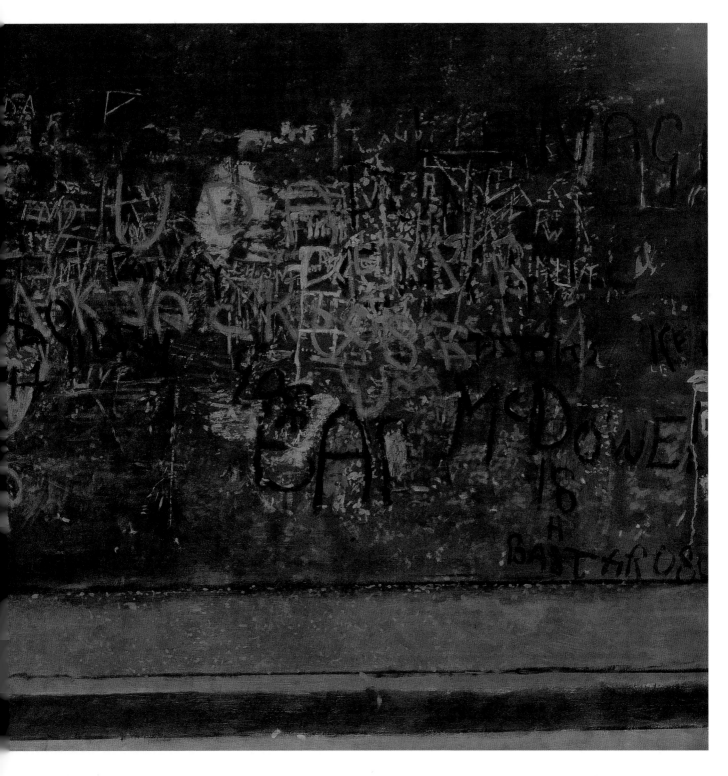

SHANKHILL WALL (1978)
Oil on canvas, 60 x 72in (152.5 x 183cm)

On the whole I do not approve of graffiti – it defaces beautiful buildings and represents pointless vandalism – but in Northern Ireland it usually contains strong, political messages and when I saw this wall in the Shankhill Road I thought it looked as beautiful as any landscape. The experience reaffirmed my belief that beauty is in the eye of the artist and that an old crumbling wall in Belfast is perfectly justifiable as a subject for painting. The appeal of this type of subject lies in the abstract patterns of shapes, textures and colours on an almost two-dimensional surface, like the façades of churches and cathedrals.

95

SNOWSCAPES

The linear horizontal and vertical arrangements that partly attract me to urban subjects are not as evident in summer landscapes when the scene is alive with the rhythmic movement of trees and abundant foliage. I am much more inspired by the structure of the landscape in winter when you can see the anatomy of the bare trees and the tension of their linear forms cutting into the sky, like the telegraph poles and wires in urban scenes. This is why I am especially drawn to painting the landscape when it is covered in snow and the trees are stripped bare of leaves; then you are left with a basic framework, often with strong vertical elements, and accentuated tones and colours based on earth colours, silvery greys and wonderful rich darks – perfect for an artist who is interested in the tonal expression of the effects of light on a subject.

Snow has the influence to transform even the dullest subject into something visually exciting. The first painting I remember making was of people skating on a frozen reservoir; later my back garden, a small area of grass with an air-raid shelter in the middle, became a source of inspiration in the winter when the grass was covered with white snow, transforming the wooden slatted fencing, so

SNOW AT SAMPFORD SPINEY (c1978)
Oil on canvas, 36 x 48in (91.5 x 122cm)

I was snowed in for two weeks and was so inspired by the scenes outside my studio that I painted almost enough work to fill an entire exhibition. Unfortunately I ran out of materials so I worked on an old canvas and used household white undercoat in place of zinc white to paint this composition, which I kept as I knew it would be technically unsound; in fact it has now started to crack. Nevertheless, it is a favourite painting, completed entirely on the spot in freezing conditions. I worked for fifteen minutes at a time, interspersed with periods in the studio to warm up before going outside again. The cold and inconvenience were worth it: to capture the essence of a subject you need to experience all aspects of it.

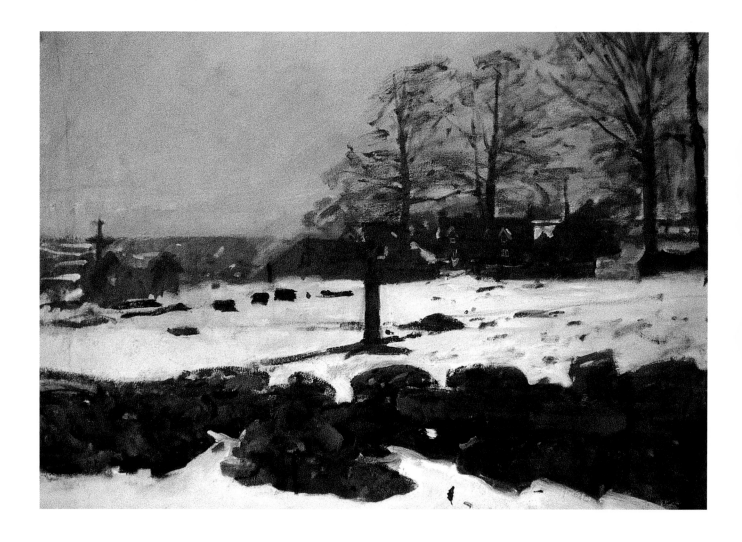

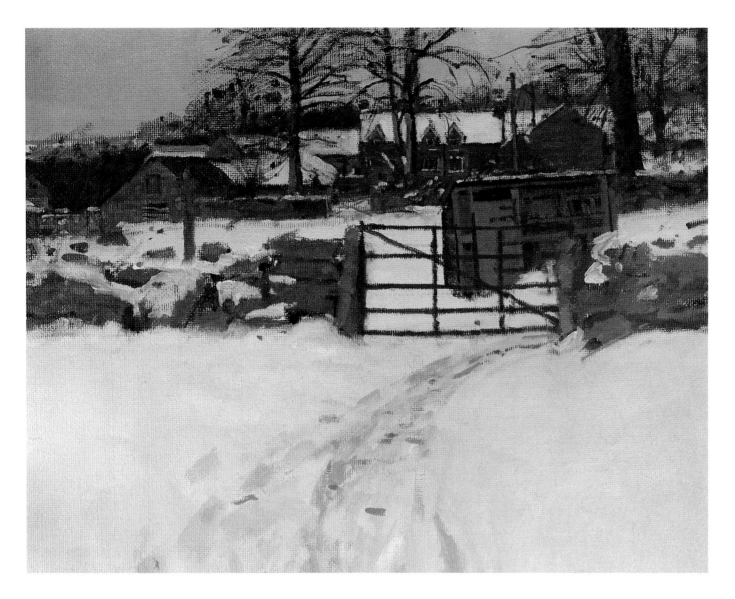

THE MANOR HOUSE, SAMPFORD SPINEY (*c*1978)
Oil on canvas, 20 x 30in (51 x 76cm)

Painted near my studio on Dartmoor, which I owned for around eighteen years specifically so that I could paint the snow in winter. In my snowscapes, as in my beach pictures, I often make the simplest area of the composition the bottom part rather than the top. Here, at least half the composition consists of snow, and although it can be a mistake to divide a composition into two equal parts, this painting supports my assertion that there are no hard-and-fast rules in painting.

drab in the summer, into a multitude of rich greys and browns. Years later, I clearly remember the excitement on a cold January morning of seeing the snow-covered view from my kitchen window of roofs and chimneys and power station in the background. Of course, painting outside in a snow-covered landscape can be inconvenient to say the least, but I believe that if you find an image that excites you, you should immerse yourself in it, whatever the conditions. In any case, the cold of winter can be great for concentration; in addition you are less likely to attract the unwelcome distraction of curious onlookers – you can be alone with your painting.

When I paint snowscapes after a long break, I usually start by working on a small scale. It can be a mistake to throw yourself into a large composition too quickly and before working up to it through a series of smaller studies. Working on a small scale enables you to capture the essence of the subject with breadth and spontaneity and can give a painting clarity. One aspect of painting snowscapes that I especially enjoy is the opportunity to work with broad, simple areas of tone and colour.

BEACH SCENES

Of all the subjects that have inspired me during my career, my dialogue with the beach in summer has endured the longest, for two main reasons: the activity of the figures, which brings the scene to life, and, more importantly, the light. I see summer beaches as populated landscapes, flooded with sunlight and invariably full of colour.

The first place to inspire me as a subject for painting was Brighton beach. Since then I have been attracted to paint beaches that are packed with deckchairs, day trippers, holidaymakers – places full of bustling movement. When I began to work in Cornwall each summer, Sennen beach provided the ideal subject matter: deckchairs were replaced by colourful windbreaks, Brighton pier by rocky headlands, yet I discovered a similar magic there.

The exhilaration of the beach scene is mostly to do with the opportunities it provides for capturing the constantly changing light throughout the day, and the elements that characterize the scene – the moving figures, windbreaks and surfboards – are merely the vehicles through which these light effects are expressed. For me, the magic of the beach scene evaporates during the winter, and although there are marvellous examples of paintings of cold winter days and rough seas pounding against rocky headlands, *I can only paint the beach when holidaymakers return to bask and play in the brilliant sunshine, bringing the scene back to life.*

As with snowscapes, it is important not to be too ambitious about the scale of work done *in situ* to start with, especially as the beach can be a particularly frustrating subject because the light, the tide and people can change

EVENING BEACH SCENE (c1987)
Oil on board, 8 x 10in (20.5 x 25.5cm)

I have been asked many times why the figure on the right-hand side appears only to have one and a half legs. The reason is that when you watch a moving figure you do not see all the parts of the body at once and painting the figure in its entirety would have lessened the impression of movement. For me a painting is complete when it expresses the sensation you felt at its inception.

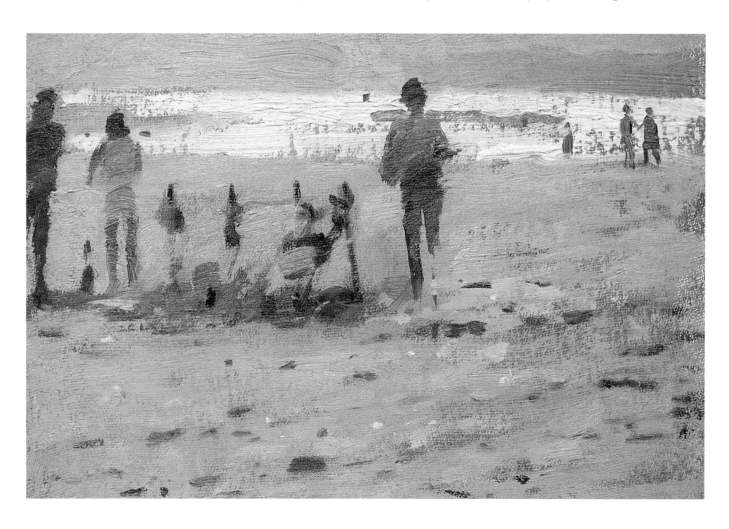

so quickly. For my first summer painting on Sennen beach I took a number of panels to work on each day, and I worked from the same spot, but limiting myself to a maximum of one and a half hours for each study. This enabled me to paint a series of studies showing the changing light throughout the day, as well as the differences between the relatively deserted, sparkling sands in the morning, through the large groups of figures at midday when the light was least interesting, to the emptying of the beach in the evening light. As the summer progressed and I felt more confident about my hand–eye co-ordination, I increased the scale on which I worked until by the end of the summer I was able to complete a 20 x 24in (51 x 61cm) canvas in one morning or afternoon session.

Initially I worked with the sun behind me. I loved the colours of the beach, the colourful bathing costumes and brightly coloured beach towels, windbreaks and surf-boards. But, probably inspired by Boudin, I later changed my position so that now when I paint beach scenes I paint looking into the sun, which is especially wonderful in the late afternoon when the figures become silhouetted against the sparkle of the sea, the village of Sennen in the background is bathed in a silver-grey light, and the entire scene is punctuated by the light flaring through the transparent coloured windbreaks.

The figures in my beach scenes are first and foremost vehicles for the expression of light and movement, which means that it is crucial to ignore the fact that they are individual human beings. Their groupings are of all paramount importance; often one figure runs into another and they are painted as generalized shapes rather than

SENNEN SURFERS, EVENING (*c*1992)
Oil on board, 8 x 10in (20.5 x 25.5cm)

It was late afternoon and, having been painting all day, I was in full flow. I painted this scene very quickly to capture the sense of the sparkling light on the water and the surfers walking into the incoming tide. This is typical of the rapidly painted, expressively spontaneous study that I would love to achieve on a larger scale, retaining the sense of immediacy of the sketch.

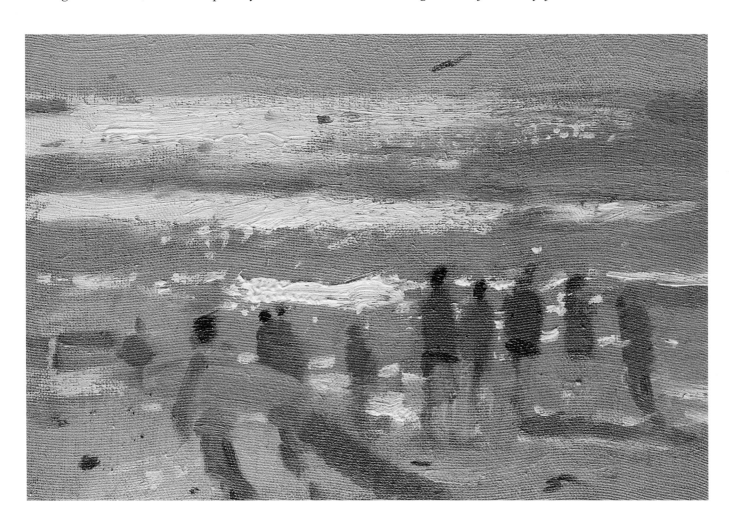

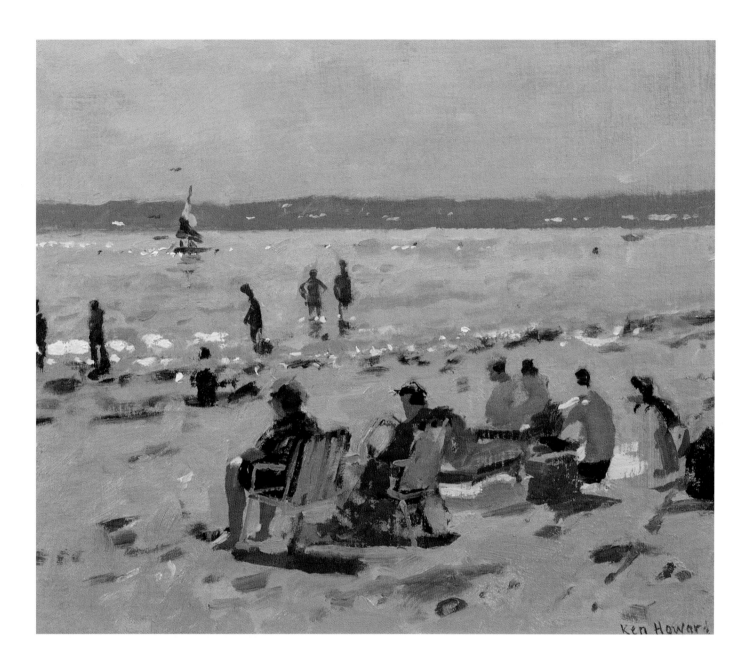

LATE AFTERNOON, MARAZION (1997)
Oil on board, 8 x 10in (20.5 x 25.5cm)

The inspiration here was the evening light, the warm sky, and the light reflecting on the surface of the water – delicious!

particular people. Boudin was a master at painting wonderful juxtapositions of figures against the simple mass of the sky, and equally, for him, detail such as feet or faces were distracting.

Very often I am attracted to subject matter to do with the past – architecture full of wonderful variation and craftsmanship such as in Venice – but for me the beach becomes more and more exciting as the years pass, with its windsurfers, surfboards, windbreaks, more umbrellas, colourful wetsuits and beach furniture. I believe that Boudin would have found today's beach scenes much more exciting than those of his time.

THE RED UMBRELLA, PORTHCURNO (c1992/3)
Oil on board, 8 x 10in (20.5 x 25.5cm)

Contrary to the traditional division of a landscape painting into one-third land to two-thirds sky, here I made the beach the largest area of the painting in proportion to the other elements. Typically, the sky is a simple field of blue.

SKIES

The sky, like the light, is an ever-changing subject, never still, and an integral and vital part of the composition of an outdoor scene. As Constable said, if you do not make your skies a material part of your composition, you are neglecting one of your greatest aids in landscape painting. I am constantly astonished by the manner in which Boudin managed to capture the sky on canvas because it is difficult to do, which is probably partly why I used to prefer to paint on dull days when the sky is matt grey and there are no moving clouds. Now I favour the clear, cloudless, plain blue skies of warm, sunny days. They radiate light and act as a compositional counterbalance to the clutter and colour on the beach.

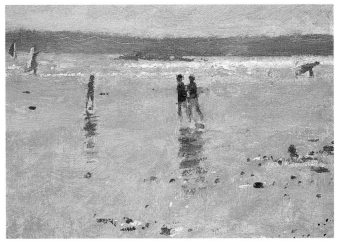

LOW TIDE, LONG ROCK (c1994)
Oil on board, 8 x 10in (20.5 x 25.5cm)

For a long time I have been fascinated by the wonderful colours of windsurfers' sails and often feel that if Boudin had been alive today he would have found the Cornish beaches amazingly exciting places to paint. The relatively neutral colours of the rest of the study emphasize the colours of the sails.

Corot said that you should always paint your sky first and relate everything in the landscape to it, which to some extent is how I approach the subject. It is similar to establishing a background first, before painting a figure against that background.

WATER AND HARBOURS

Like the sky, water is an elusive, constantly changing subject, which is full of movement and difficult to capture, yet a vital element in expressing the effects of light. It reflects the colours of the sky and is a key element in my beach scenes, although I seldom paint the sea as a subject in its own right.

Like the Newlyn School painters, I enjoy painting the movement and bustle of harbour life. I love the architectural qualities and shapes of the boats and their bright colours contrasted against the neutral greys of the harbour and sky. Like the pylons and telegraph poles in industrial scenes, the masts of trawlers provide a dynamic accent to compositions.

It is important to accept your limitations as an artist. I was told as a student that I should first recognize what they are, and then work as fully as possible within them. Although at the time I dismissed the advice, I now understand that I am inspired as a painter by light-filled outdoor scenes that include evidence of human activity. I am an urban landscape painter, not a pure landscape painter; I paint the sea as part of a summer beach, or harbour scene; I am not a natural seascape painter.

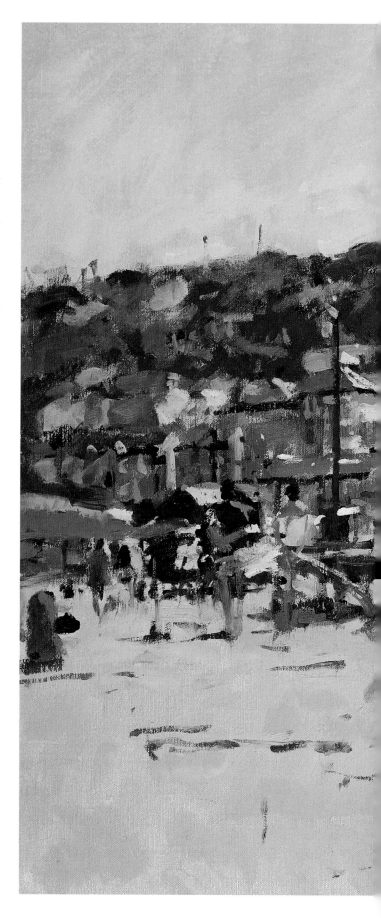

MOUSEHOLE, JUNE (1993)

Oil on canvas, 20 x 24in (51 x 61cm)

When I first moved to Mousehole I found the village almost too attractive and couldn't see how to interpret it in my own terms. However, having lived there for several years, it has become the perfect vehicle for my love of light, in this case on the roofs of the village houses, and of rich, earthy neutral colours.

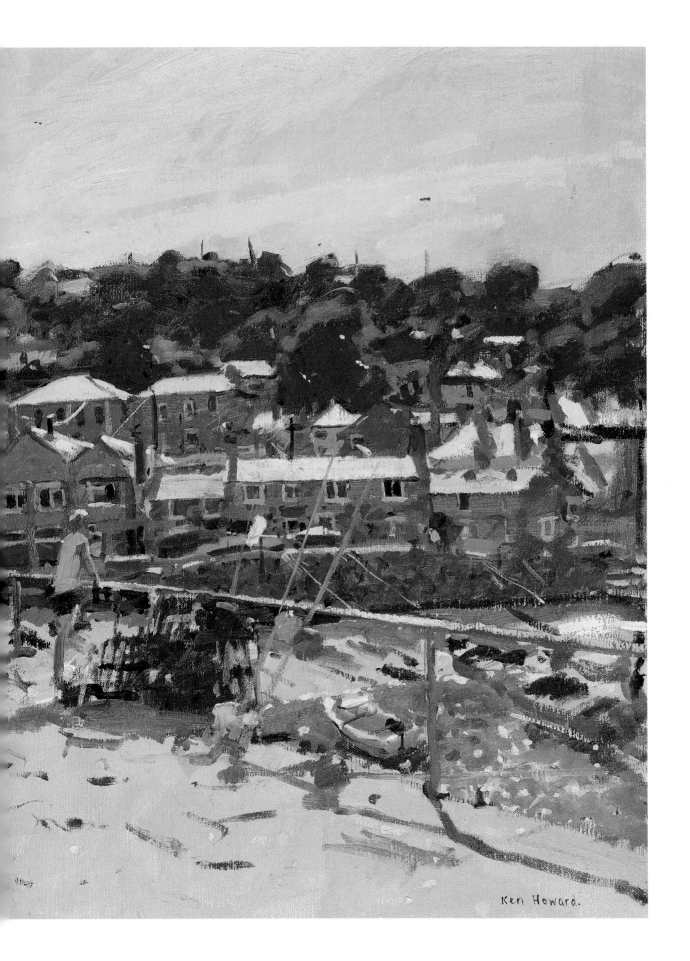

Ken Howard.

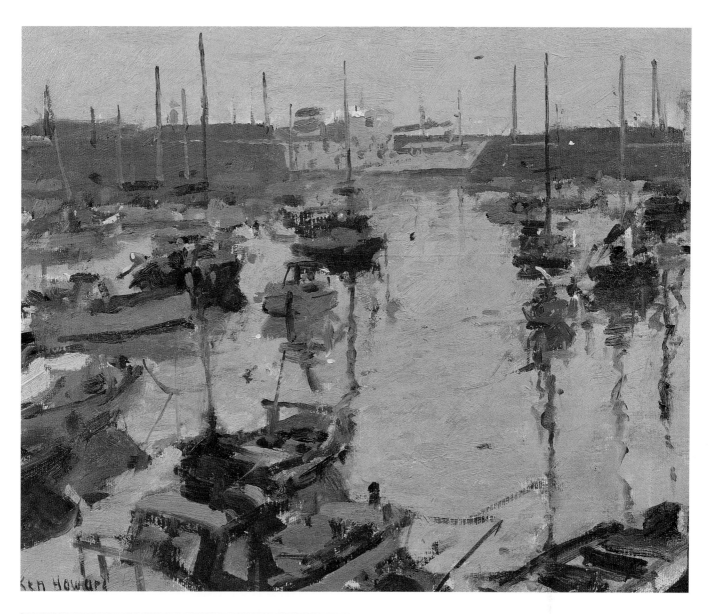

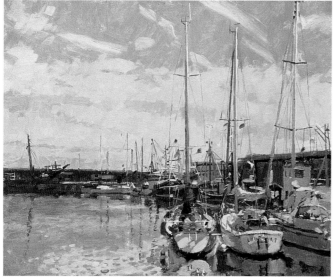

PENZANCE, HIGH WATER (1997) *(Above)*
Oil on board, 10 x 12in (25.5 x 30.5cm)

This was painted relatively early in the morning at high tide. I was especially touched by the contrast of the warm light of the sky, picked up by the water, with the cooler shapes of the boats.

THE INNER HARBOUR, PENZANCE *(c1985) (Left)*
Oil on canvas, 20 x 24in (51 x 61cm)

I was particularly interested in the sky and its reflection in the water. I remembered Corot's advice and established this area first before painting the boats and the rest of the subject matter. The inspiration for the composition was the strong horizontal/vertical contrast of the line of the harbour and masts of the boats. An advantage of painting in the enclosed space of the harbour is that the water is still and the reflections clearer.

VENICE

The quality of the light in Venice attracts me to the city more than any other place and has provided me with enduring inspiration since I first started to paint there in 1975. The experience is similar to that of painting on the beaches in Cornwall, the proximity of water generating an incredibly vivid light with the advantage that in the summer in Italy the sun often shines consistently from early in the morning until dusk.

In addition to the coruscating effects of light on water, the *campi* and narrow Venetian streets are natural vehicles for expressing light. Although initially the topography fascinated me – the façade of St Mark's, so wonderfully painted by Sickert; the rich, ornate detail of the Salute; the *palazzi* on the canals – I see Venice essentially as a place full of light-reflecting surfaces and ornate architecture silhouetted against rich, warm, iridescent skies.

The problem, of course, with painting a subject that has been painted many times before is how to overcome the initial concern about how to see and express it differently

WHITE PARASOL, S MARCO (1997)
Oil on canvas, 40 x 48in (101.5 x 122cm)

One of a series of the façade of St Mark's, inspired by Sickert. Other paintings in this series include views bathed in strong sunlight, or seen through a haze of rain and reflected in the flooded square. I have painted the scene at various seasons and times of the day.

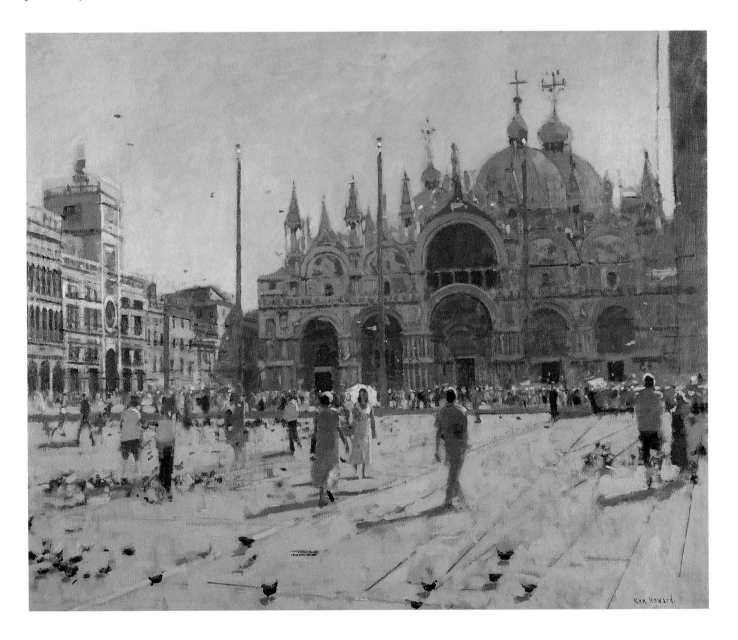

partic from other artists' interpretations. Many artists who influenced my development have painted Venice, notably Turner and his magical evocations of the city dissolving into the lagoon and the Grand Canal; Sickert expressed the light and shade of the *campi* and churches beautifully; more recently, friends Bernard Dunstan, Diana Armfield and John Ward have encapsulated the essence of the place in their own, different ways.

How can an artist new to a place like Venice find something original to say? At first I fell into the trap of thinking that I should find new viewpoints and I painted the narrow, dark alleys around the Accademia and Campo San Barnaba. The results closely resembled my early paintings of Southall railway sidings, the difference being that these were dark and horizontal while the Venetian scenes were dark and vertical! In my experience it is better to avoid being inhibited by your preconceptions and allow the subject to impose itself on you, rather than vice versa. It is nonsense to think that another artist may have had the last word about a particular subject. Whether it has been painted a thousand times before or not, it will never before have been painted through *your* eyes. As long as you are true to yourself, and responsive, your interpretation of a subject will be fresh, exciting and personal. This became one of my key philosophies and liberated me to paint the fabulous light of Venice in my own language. My aim when people look at my Venetian paintings is to invite them to experience the place through my eyes.

Once you have found a subject that inspires you, you can paint it time and again, on different days, at various times of day, and in different seasons and weather conditions, because on each occasion the subject will be different. Monet's series of paintings of haystacks and of Rouen cathedral are wonderful examples of this. I am just as inspired by the haze of the morning light and the effects of the early spring fog in Venice as I am by the strong midday sunlight. The city's architecture provides a marvellous basis for the expression of these changing light conditions. Indeed, I have spent a large proportion of my career painting the same subjects.

THE PIAZETTA, WINTER (1998)
Oil on board, 10 x 12in (25.5 x 30.5cm)

When I first started painting in Venice the inspiration for me was the strong sparkling light, but over the years I have come to love Venice in the winter when it is characterized by silvery greys and is full of my beloved reflections in wet surfaces.

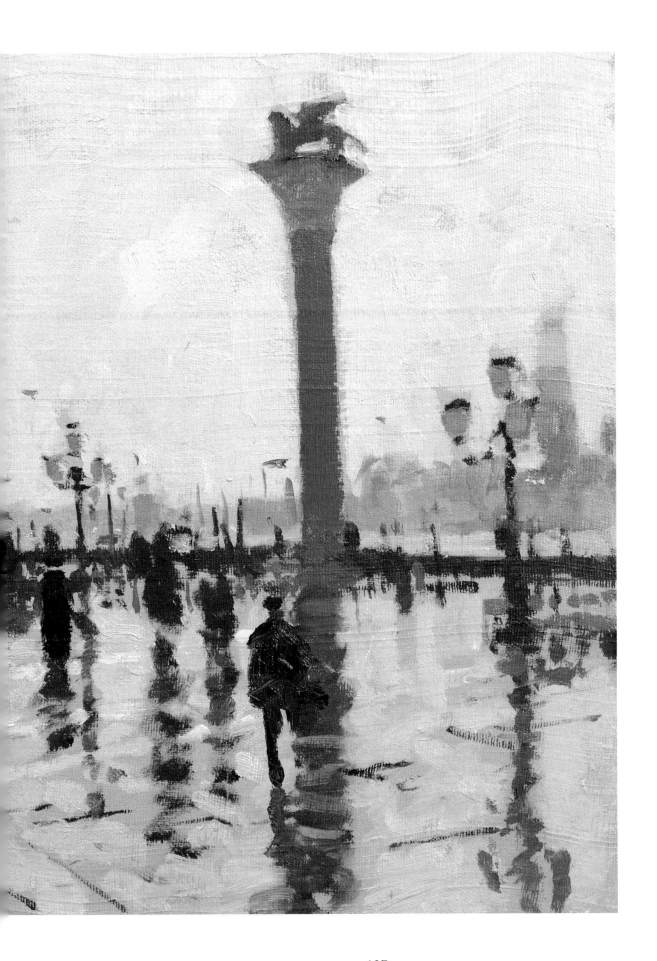

Chapter Seven

INDOOR THEMES
AND INSPIRATIONS

As with outdoor subjects such as the Cornish beaches, Venice and winter snowscapes, the interior subjects that hold a particular fascination for me are ideal vehicles for the expression of light. Strong sunlight shining through a window creates wonderful warm and cool contrasts, for example, and I have an enduring interest in painting the figure because the human form continually offers new discoveries about light, tone, colour, movement and rhythm.

DORA AT ORIEL (1995)
Oil on canvas, 40 x 48in (101.5 x 122cm)

The studio is an expression of me because everything in it has significance in terms of my painting and personal life. The painting on the easel in the background is an Indian scene based on a watercolour study, my painting table occupies the foreground, and the model is Dora, whom I first met in Venice and who has since become my most-painted model and close friend.

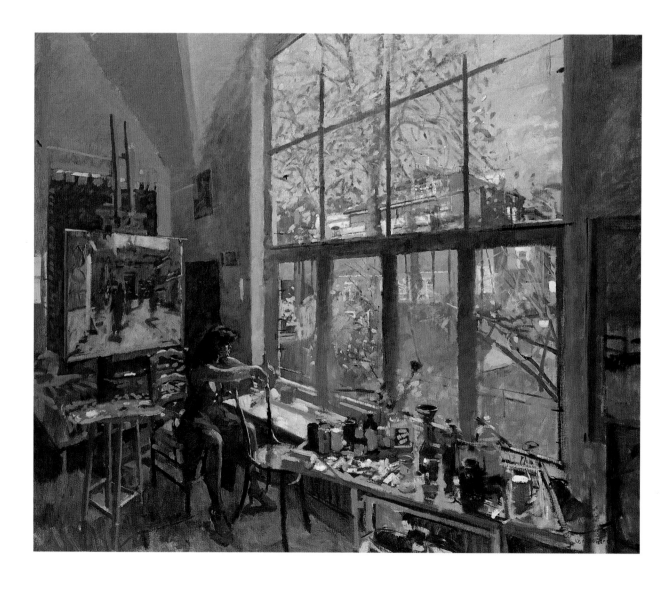

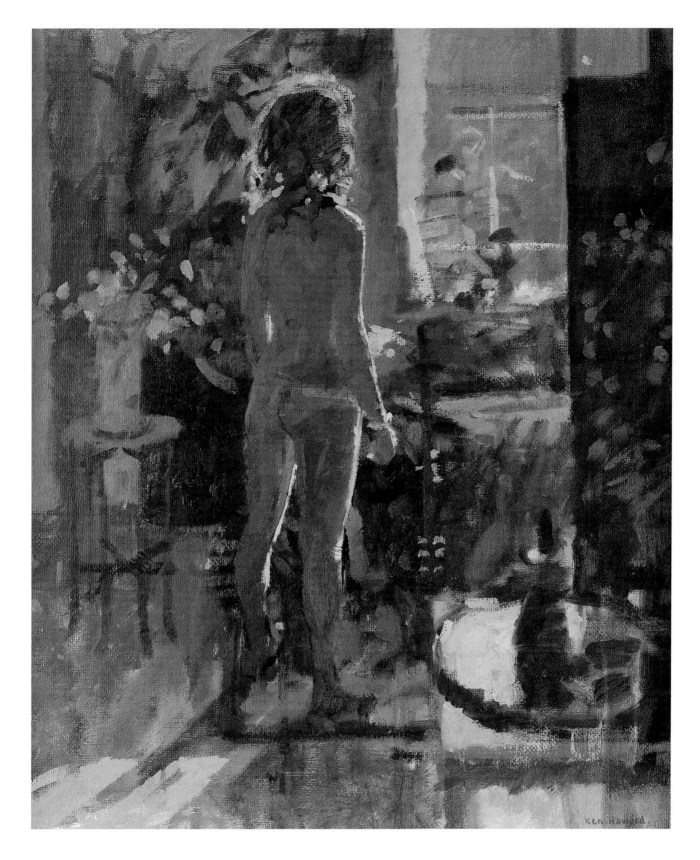

DANIELLE, EARLY MORNING (c1985)

Oil on canvas, 24 x 20in (61 x 51cm)

*I love the back view of the figure, partly because the back presents a simple
shape. Standing against the light the tones are simplified while the brightly
lit side of the figure catches the light. This painting encapsulates how I love
to use the figure as a vehicle for light.*

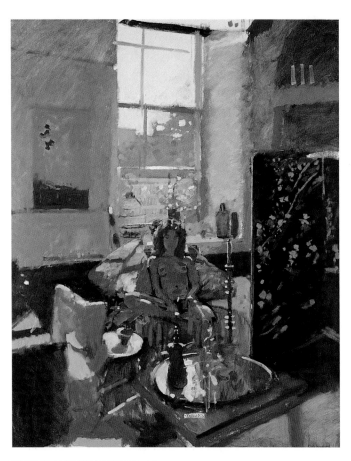

VALERIE, MORNING LIGHT (1989)
Oil on canvas, 48 x 40in (122 x 101.5cm)

The reflection of the light on the brass tray and the way it strikes the model's shoulders and hair are obvious inspirations for this painting, but I was as interested in the subtle changes of tone and colour in the relationship between the poster and the wall.

For many years after leaving art school, I had little interest in painting the nude figure because it epitomized 'art-school art' for me. I returned to the subject when I moved to my London studio in South Bolton Gardens in 1974, where my landlady continued to hold weekly life-drawing sessions from a hired model for a group of friends. Seeing them work influenced and changed my perception and I began to see the model less as an object for academic study and more as a vehicle for the interpretation of light. I started to hire a model and settled into a pattern of work in which I worked – and still do – from a model for the first three hours of most days.

The most important aspect of the model is how she (I prefer to paint women) sits or stands. Although I do like to establish a rapport with her, personality is not a critical factor; rather, I need someone whose natural pose is full of movement, not too stiff and self-conscious. Many of my models are therefore dancers because they automatically strike interesting, natural-looking poses, full of movement. This is crucial because convincing figure paintings are dependent on the artist's ability to capture the energy and dynamic movement inherent in the human form, which is largely about the right choice of pose, as well as the vitality of the painted marks.

Individual parts of the figure are not difficult to draw or paint as isolated components; the hardest thing is to fit these into a coherent whole so that the figure looks as if it could move. Rhythm and a sense of movement can only be achieved by recognizing that every part flows into, and is dependent on, another one; if you try and treat each part separately you will be lost. When I taught figure drawing in the 1960s I lost patience with students who argued that a hand was a millimetre out of place. To me, this indicated their lack of concern for the essential rhythms of the figure as a whole, an attitude that typified the art-school approach I rebelled against when I left college.

THE CLOTHED FIGURE

I spent several years painting only from the nude until one morning in my studio in Cornwall I was overwhelmed by the sight of the model, before we started work, standing in front of the east-facing window, with the sunlight piercing through the fabric of her robe. The effect was similar to the light flaring through the windbreaks on Sennen beach.

I began to ask my models to dress in transparent-coloured fabrics, then, partly inspired by Whistler's use of Oriental studio props and the Japanese influence in some of his figure painting, I asked them to wear brightly coloured kimonos, and introduced coloured paper parasols and Japanese-style screens into the studio to act as light-catching devices.

When painting the clothed figure, it is especially important to be aware of the contrast of the colours of the clothing with the subtlety of flesh colours. This has always fascinated me, to the extent that when I came across Toulouse-Lautrec's *Seule,* a beautiful painting of a prostitute lying on a bed, naked except for a pair of black stockings, I started exploring this relationship between an obvious, dark colour and the translucent, light-reflecting, light-absorbing colours of skin, ever-changing with the quality of the prevailing light.

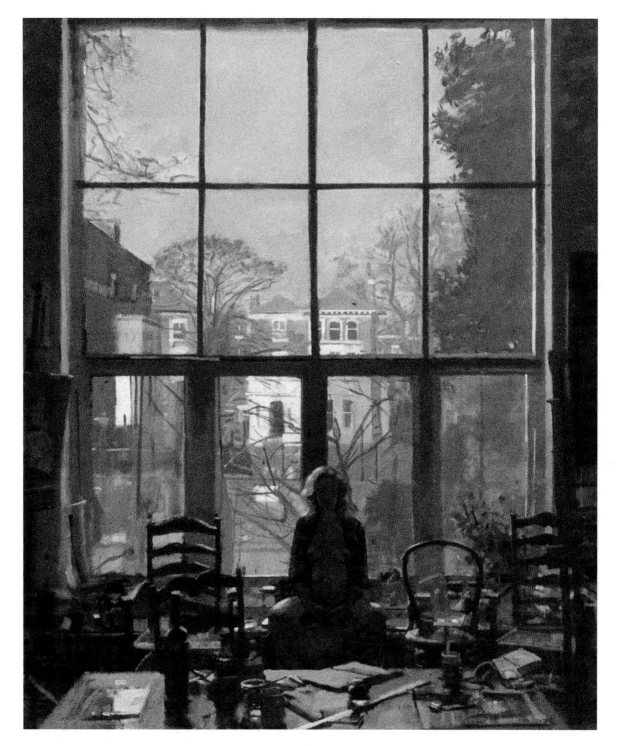

MARIKA WAITING (c1985)
Oil on canvas, 48 x 40in (122 x 101.5cm)

*Marika, a professional dancer, had been my model for some years.
When she became pregnant I decided to paint a series to document the stages
of her pregnancy. This was painted early in the spring in London and is my
favourite painting of the series, partly because I like the symbolism of
the relationship between the heavily pregnant Marika and the spring
landscape outside.*

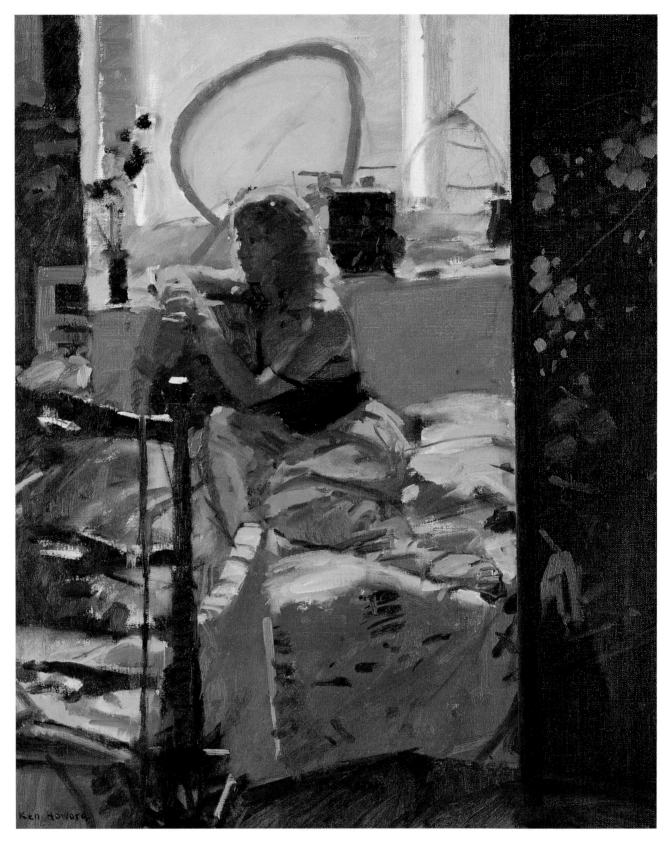

LORRAINE (c1994)
Oil on canvas, 24 x 20in (61 x 51cm)

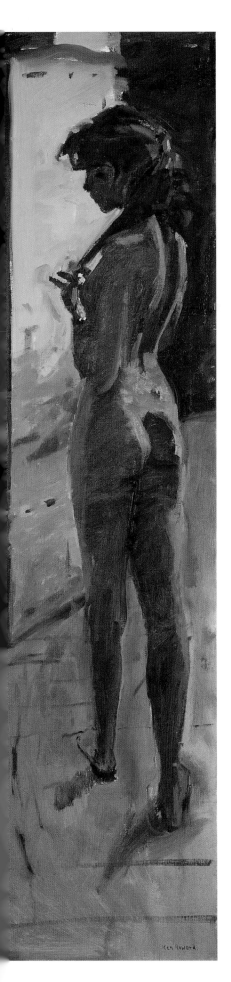

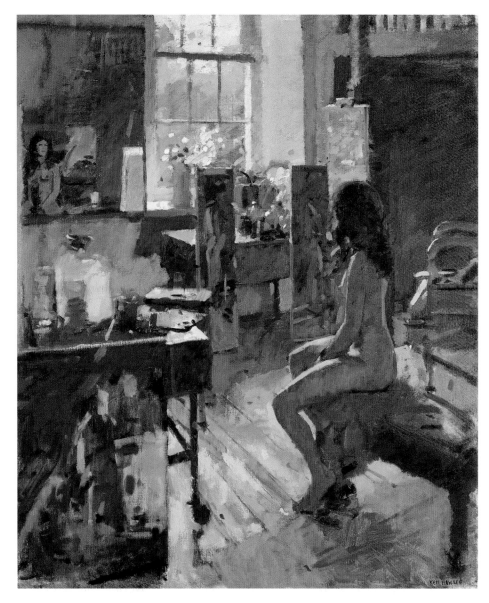

SARAH, STUDIO REFLECTIONS *(c1991)* *(Above)*
Oil on canvas, 30 x 25in (76 x 63.5cm)

This is an unusual composition for me. My idea was to surround Sarah with some of the paintings of her in the studio in Cornwall, and paint her juxtaposed with her image reflected in the mirror beside the window, so you can see her side and front view in the same painting.

HOMAGE TO SARGENT *(c1990)* *(Left)*
Oil on canvas, 48 x 12in (122 x 30.5cm)

I took this composition from a painting by John Singer Sargent which I have loved for years. Being influenced by other painters is part of the development of an artist. I believe we must learn as much as possible from the painters we most admire; copying from their work, or making transcriptions, as I have done here, are good ways of doing so.

113

Most important for me, of course, is the fact that clothes and fabrics not only echo and accentuate the inherent rhythms of the figure, they also emphasize the light aspect. As my greatest passion is for working *contre-jour*, the sight of the light streaming into my studio and illuminating the silks and light fabrics worn by the model became an obsession.

WRAPPED FIGURES

This led to painting the figure wrapped in a single white sheet. It seemed a logical development, prompted partly by my reaction to a photograph of a wrapped figure in an exhibition of photorealism in Paris. Using a white sheet removed the patterns and colours of the kimonos, taking the painting of the figure back to considerations of tone, which is when I am probably at my happiest. This is when I get a real buzz from my canvases. When the tonal values work well in a painting, I feel that I have come closest to what I want to achieve in painting.

STUDIO INTERIORS

Another intriguing aspect of painting the figure is its relationship to the surrounding interior space. This was another important revelation when I first moved to the studio at South Bolton Gardens and started to paint from the model. The studio was originally owned by the portraitist Sir William Orpen. He named it Oriel after the house in Ireland in which he was born, and I have recently bought the property next door to enable me to get rid of the dividing wall and restore the studio to the one large space he enjoyed during his occupancy. It is perpetually bathed in cool north light, ideal for a figure painter who needs a consistent, even light. The sun enters the room only late on summer evenings, in contrast to the brilliant, almost Mediterranean light that floods St Clement's Studio in Cornwall, where I paint during the summer.

My studio is a natural working environment, and an expression of me. It is rarely tidied up, with cluttered surfaces filled with old jars, empty turps bottles, palettes, coffee cups – all natural still lifes – in which the changing juxtapositions of forms provide the perfect vehicle for expressing light and for seeing the figure *contre-jour*, silhouetted against the windows, and affected by the reflections within the room.

It also offers the perfect background setting for the model and acts as a helpful aid to painting the figure. For example, when working on a canvas I establish the initial

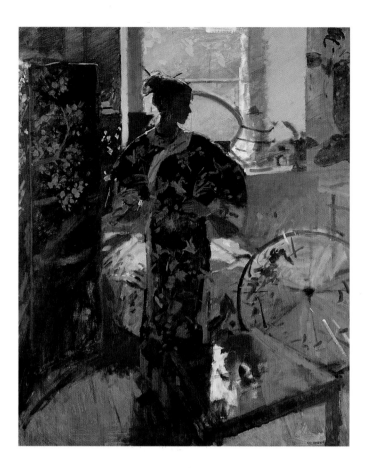

LORRAINE, BLACK AND YELLOW (c1989)
Oil on canvas, 48 x 40in (122 x 101.5cm)

The inspiration was the effects of the light on the fabric of the model's kimono and piercing through the transparent yellow parasol, contrasted with the apparent lack of colour of the screen in shadow. I became focused on the abstract play of black against yellow throughout the composition, hence the title, although I also saw the model as the equivalent of the strong-willed Turandot from Puccini's opera, which I listened to a lot at this time. Playing music while painting overcomes the need to make conversation with the model, and often my models also become great opera enthusiasts!

background colours first, before starting to paint the model, partly because the subtle colours of the figure are affected by the more obvious surrounding colours. It is also easier to define the rhythms and movement of the figure against the verticals, horizontals and other rhythms in the clutter of the studio (it is impossible to see the figure properly in isolation). The more the studio became a vehicle for expressing light, the more important was the role of the paraphernalia within it in accentuating the play of light throughout the interior space.

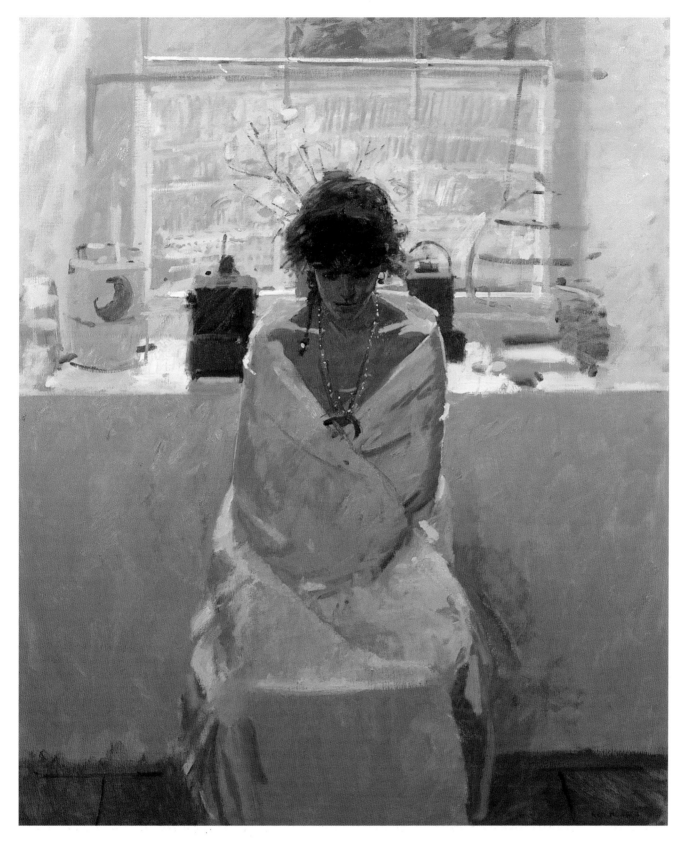

SARAH, HARMONY IN WHITE (c1992)
Oil on canvas, 48 x 40in (122 x 101.5cm)

The model wrapped in a white sheet has inspired me for the past five or six
years, and this is probably my favourite painting of the series. The simplicity
of the colour harmony and the subtle play of tone in order to express the sense
of light are features that I could experiment with for the rest of my career.

Occasionally I have painted the interior before introducing the model, but this has always been disastrous since each element has a bearing on the rest of the composition. On the other hand, I sometimes start a painting with the model present, and in the case of larger canvases, continue to work on the interior without the model in place. This allows me to develop the subtle modulations of tone within the studio – when the model returns I can quickly achieve the correct tonal values of the figure.

Interiors are all about people for me; I don't think I have ever painted an interior without a figure being present. The figure becomes the focal point and defines the scale of a painting, which continues to engage me as a compositional problem. I have varied the scale of the figure in my interiors throughout my career: sometimes they are about half the height of the canvas, at other times, when they are much smaller, the interior becomes more important in proportion.

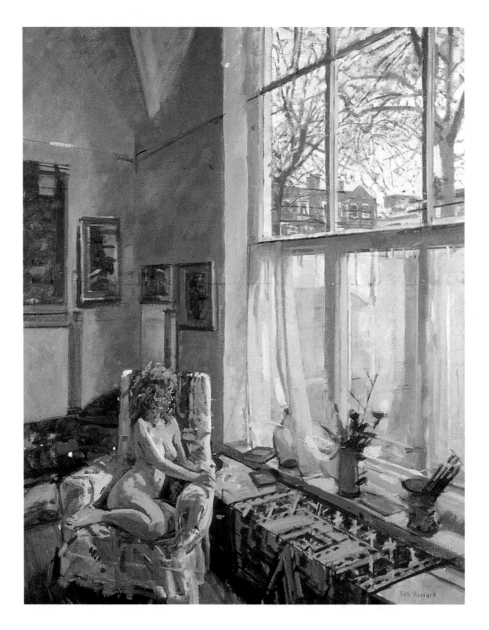

SARAH AT SOUTH BOLTON GARDENS (1996)
Oil on canvas, 48 x 40in (122 x 101.5cm)

*I saw this subject, as I often do, during the model's rest. I prefer to find the
subject rather than arrange it.*

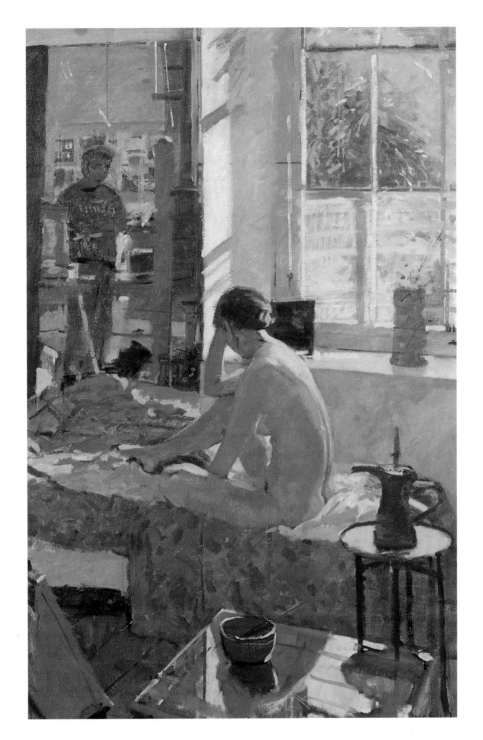

ARTIST AND MODEL (1997)
Oil on canvas, 48 x 30in (122 x 76cm)

I had great difficulties with this painting, partly as a result of the strong colours of the fabric on which the model was sitting. It was only when I began to use the same colours throughout the rest of the painting that it started to come together as a whole. The artist reflected in the mirror is Bo Hilton, who sometimes joins me to work from the model. I enjoy introducing a secondary figure into my studio interiors and a mirror-image is an ideal way of doing so.

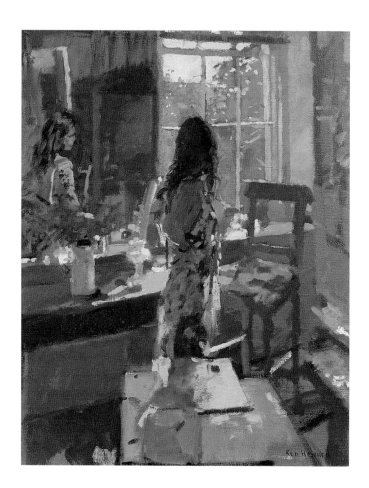

MOUSEHOLE, SEPTEMBER AFTERNOON (1997)
Oil on canvas, 16 x 12in (40.5 x 30.5cm)

I was especially interested in the brightly coloured cushion which offsets the relatively neutral colour of the rest of the picture, apart from where its orange colour is picked up in the exterior view.

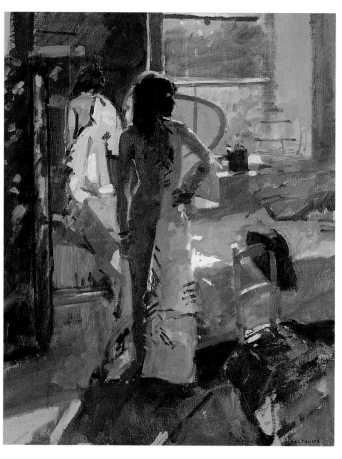

SARAH AND THE YELLOW KIMONO (c1989)
Oil on canvas, 24 x 20in (61 x 51cm)

Over the years I have collected various kimonos. Variations on this theme relate to the beach and Venetian series – they are all explorations of changes of light on a subject.

MIRRORS AND REFLECTIONS

Throughout my career I have been interested in the usefulness of mirrors for the painter, and they soon became an important element in my studio interiors. Their most obvious use is for helping you to see a painting with a fresh eye. By observing its mirror image it is more likely that weaknesses, mistakes and problems will be spotted which may not be clear otherwise.

A mirror is also a useful studio prop which, when squared up, helps you to place the elements in a composition correctly. Moreover, it enhances the effects of light by reflecting the light from the window back into the room. Another advantage is that it can show you an alternative aspect of light on a figure you are painting: for example, if

the figure is in shadow within the room, she will be seen fully illuminated in the reflection from a mirror positioned near the window.

In addition to my studio paintings, the mirror-image has been a feature in my work in different forms since my student days. My first painting to be exhibited in the Royal Academy, when I was eighteen, was based on the interior of the gentlemen's toilet at St Paul's Underground station, showing me washing my hands and the mirror-image of the wonderful mosaic pattern decorating the walls, plus the back view of two other patrons. Later, I became interested in the way that cars become multi-faceted mirrors reflecting people and places as well as the sky. Then in Northern Ireland where it seemed to

118

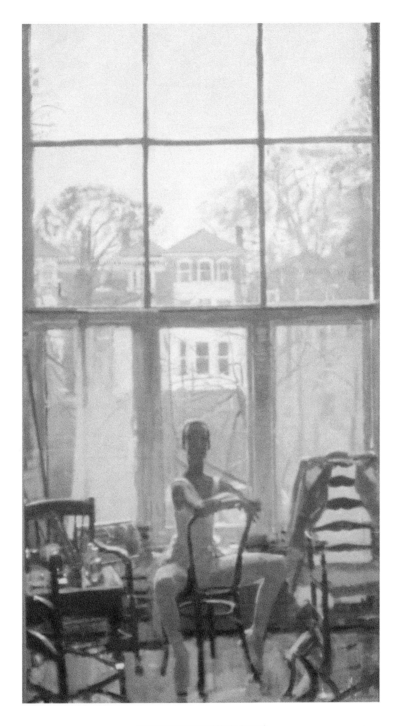

THE WHITE LEOTARD (*c*1990)
Oil on canvas, 48 x 24in (122 x 61cm)

This was painted in my London studio in which the model sat against the winter landscape outside the window. It is one of my favourite paintings, possibly because, as the model was unreliable, I was forced to stop before I was ready to, which turned out with hindsight to be at the right point! It has only one or two accents of colour. It is said that an artist needs two people in his life, one to inspire him and another to take away the picture once it's finished, a statement with which I wholeheartedly agree.

119

rain all the time, one of the key elements of my work became the reflections in puddles. There is a mystery about the mirror-image and its revelation by the artist; for some reason people, like cats, are not particularly conscious of mirror-images until they are pointed out to them.

WINDOWS

By depicting what can be seen outside a window, an interior scene takes on a whole new dimension. The inclusion of a view glimpsed through a window creates an intriguing double-image; the window gives you a frame for the source of light, and the opening up of the picture space draws the viewer into the scene.

DORA (1996)
Pastel, 8 x 10in (20.5 x 25.5cm)

Although I have not used pastel a great deal, I have started to use it in mixed-media work, partly inspired by the gift from Norman Hepple's widow of an incredible collection of his pastels. This is my first pure pastel study, in which I enjoyed exploring the process of using the medium; often the first thing you do in a new medium, or the first painting inspired by a new location, has a quality that can never be recaptured.

DORA, HARMONY IN WHITE (1997)
Oil on canvas, 40 x 48in (101.5 x 122cm)

In this and **The White Leotard** *my inspiration was the beautiful, subtle variations of silver grey in a white-on-white theme.*

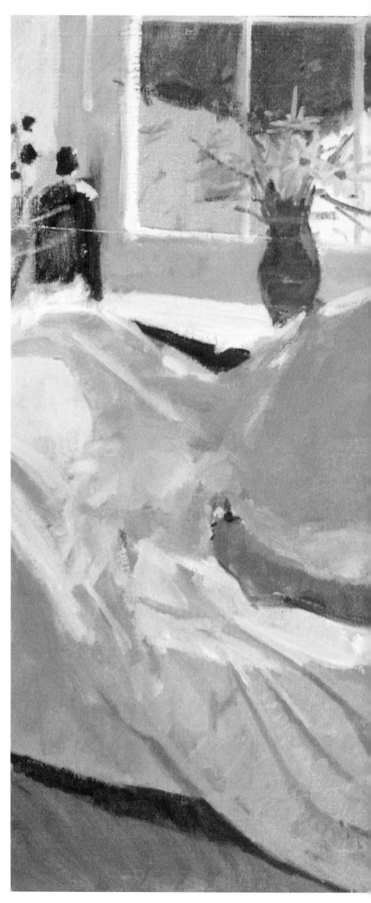

120

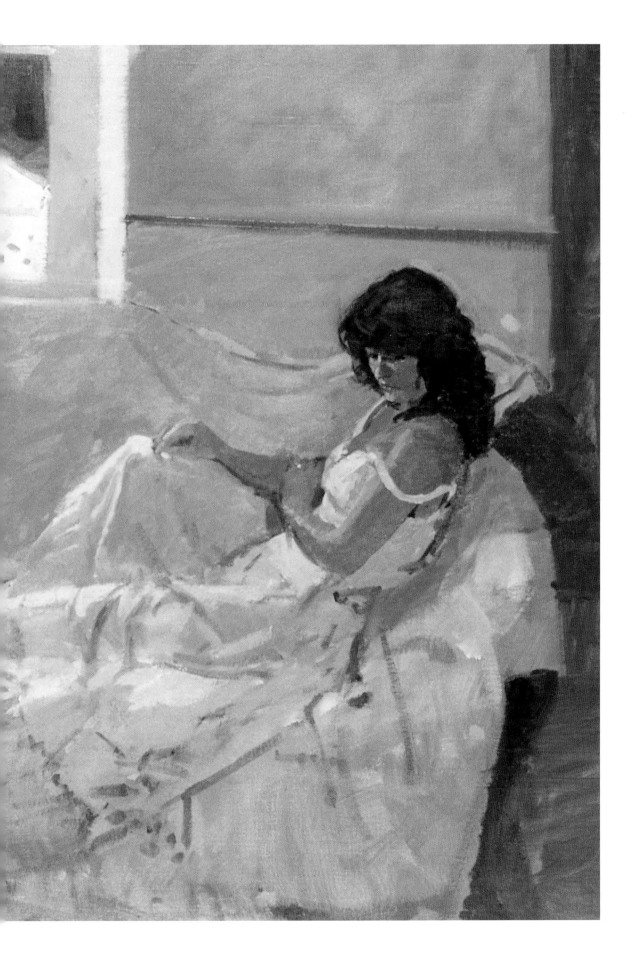

Another reason for including the view outside is that it contributes a constantly changing feature in terms of the different colours of the seasons. As soon as you introduce the landscape element into the picture, it affects how you see the interior. In the autumn, for example, the colours inside my London studio contrast with the warm colours outside, while the reflective surfaces reflect the outside hues. The whitewashed studio walls show the greatest changes: in the autumn they have a blue cast which compensates for the warm colours outside; in the summer they have a red tone in relationship to the lush greens outside. This effect is more pronounced in my London studio because, being north-facing, the light directly affects the outside elements, not the colours inside, except in terms of these colour relationships.

One of the attractions of my studio in Cornwall is that, by contrast, it has a greater feeling of light because the windows are east facing and the light pours directly through them. In the summer, between 7am and 8am, you can almost watch the shadows moving; the sun absolutely floods in and the studio becomes a space through which light moves.

THE VENETIAN MODEL (1996)
Oil on canvas, 40 x 48in (101.5 x 122cm)

One of a series of figure paintings using a friend's studio in Venice as the setting. The studio is a wonderful reflection of him, and the Giudecca canal outside is visually superb. I loved the strong pattern of vertical and horizontal lines in the windows, the balcony beyond, and the objects in the studio. I am constantly moved by the strong formal effect of these relationships, offset here by the curves and rhythms of the model and chairs.

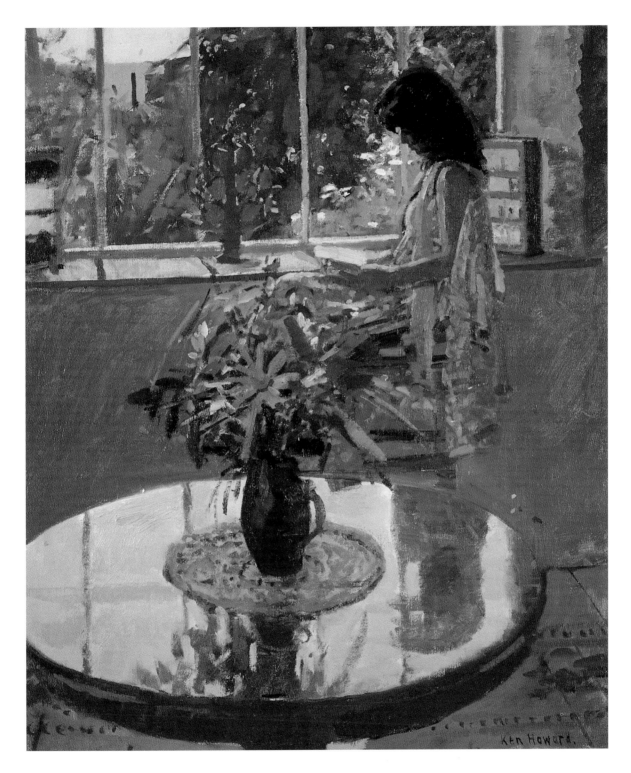

DORA, HARMONY IN GREEN (1997)
Oil on canvas, 24 x 20in (61 x 51cm)

One of a series based on a table in my living room in Cornwall, which often takes the place of my studio as an interior setting for a figure painting. The room is full of light as it has windows on three sides, with the main window facing south. I loved the arrangement of the colours and pattern of the dress in relation to the flowers and exterior.

I seem to have gravitated towards studios which are high and spacious. Oriel is very high, and my St Clement's studio is also large with a ceiling like a great dome of sky.

When I become too old to go outside to paint, my studio is large and varied enough to provide plenty of subject matter and inspiration, especially as the light is constantly changing.

STILL-LIFE AND FLOWER PAINTING

Although the natural 'table still lifes' in my studio are important features in my studio interiors as vehicles of light, I am not yet moved to make these a subject for paintings of still lifes in their own right since they are too static. On the other hand, I have started to explore floral groups. With their wonderful rhythms, shapes and colours, and the fact that they are living, vibrant forms, I see flowers as vehicles for expressing how light can shine through their translucent petals and illuminate them as if from within.

Moreover, they contain the element of change I seek in a subject. The fact that they can wilt so quickly, in addition to the changes in the light, means that you have to concentrate fully to capture your impression before the subject changes. I am inspired by the urgency of trying to capture things which seem almost impossible – which sounds tortuous but it does contribute to the directness and vigour of the work.

As my treatment of the figure, I like to paint 'natural' flower still lifes, which means that rather than arranging the objects, I will move my viewpoint until I see an aspect of the subject that touches me. My late wife, Christa Gaa, who painted wonderful still lifes, spent an enormous amount of time arranging her subject, whereas for me a still-life subject must be an arrangement that has happened naturally, and which implies the presence of the person or people responsible for it.

For me, painting is all about balance – achieving the perfect balance between form and content. Great painters, including Goya, Vélasquez, Rembrandt, Degas, Sickert, Stanley Spencer and Gwen John, are neither too illustrational – in other words, too concerned with the content of a picture – nor so abstract in approach that you find you have lost touch with the subject. With still-life painting the content is the arrangement of the objects, or flowers, and the implied human presence, and the form is what I

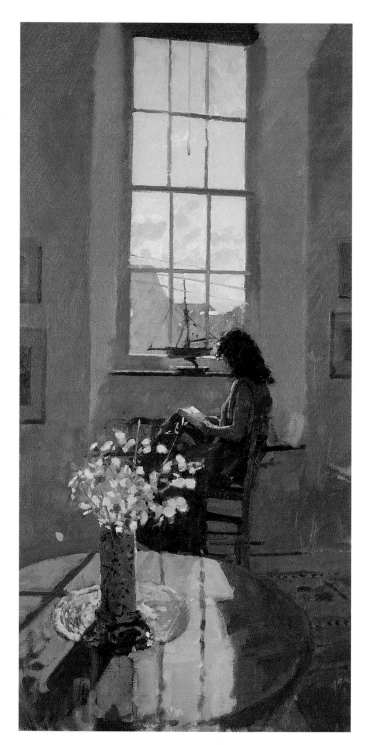

DORA, HARMONY IN BLUE (1996)
Oil on canvas, 48 x 24in (122 x 61cm)

I started this painting on a dull day and made the mistake of returning to it when the light was much brighter, so I had to overpaint the original image to describe the new light conditions. I should have started again on another canvas. That said, when you struggle with a painting it can often lend the final image a quality unachievable in a painting completed in one session.

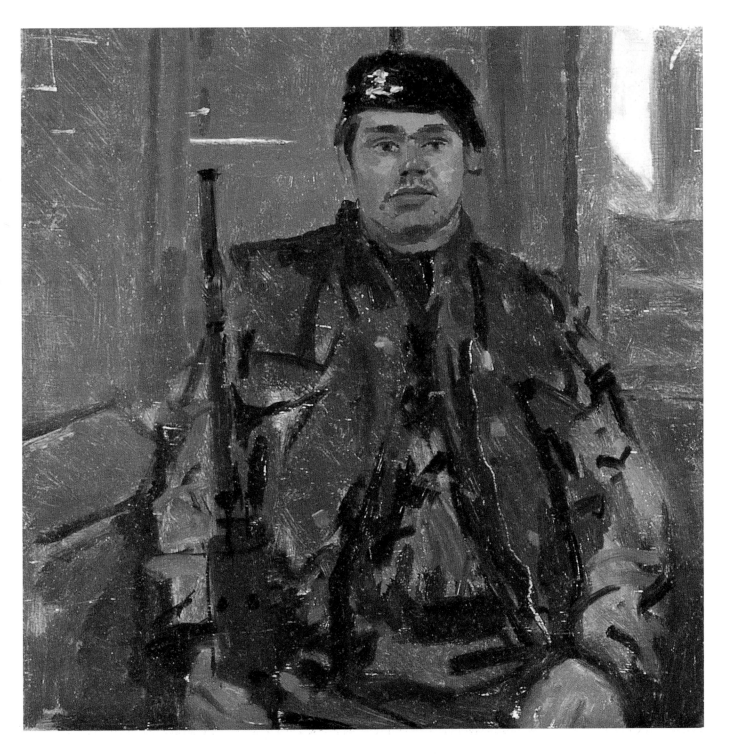

SOLDIER IN THE CREGGAN (1973)
Oil on canvas, 16 x 12in (40.5 x 30.5cm)

Although I don't paint many commissioned portraits now, I am often moved
by people seen in their natural environment or, as here, in an unnatural
environment such as an army post in the Creggan estate in Londonderry.
I had been painting outside, but when I was forced inside by the rain I was
inspired to paint this soldier and completed it in one sitting of
around three hours.

125

am able to contribute, not by arranging the set-up, but by moving myself into a position in which the shapes, tones and colours begin to mean something in painterly terms. Nature gives me my content; I give the painting, whatever the subject, its form.

After all, all painting is to a degree abstract in the sense that it is an arrangement of shapes and colours on a flat surface that in some cases becomes an equivalent for a visual sensation received by the artist. Figurative painting is no more about copying reality than non-figurative painting, but for me the subject of the painting is just as

relevant today as it was a thousand years ago, or even further back. Content is as relevant to painting as the theme is to a symphony or the plot is to a novel.

At the start of this book I said that I would be concerned only with my personal view about painting. You may have found yourself in profound disagreement with my ideas and practices, in which case I hope that I have at least stimulated you to consider other ways to achieve your goals. If, on the other hand, you have felt sympathy with them, I hope you will feel inspired to incorporate them into your own way of working.

SPRING BOUQUET, MOUSEHOLE (c1989)
Oil on board, 10 x 8in (25.5 x 20.5cm)

*This bouquet of flowers was brought by a friend who had been invited for
dinner, and is typical of my wish to find rather than to create
my still-life subject.*

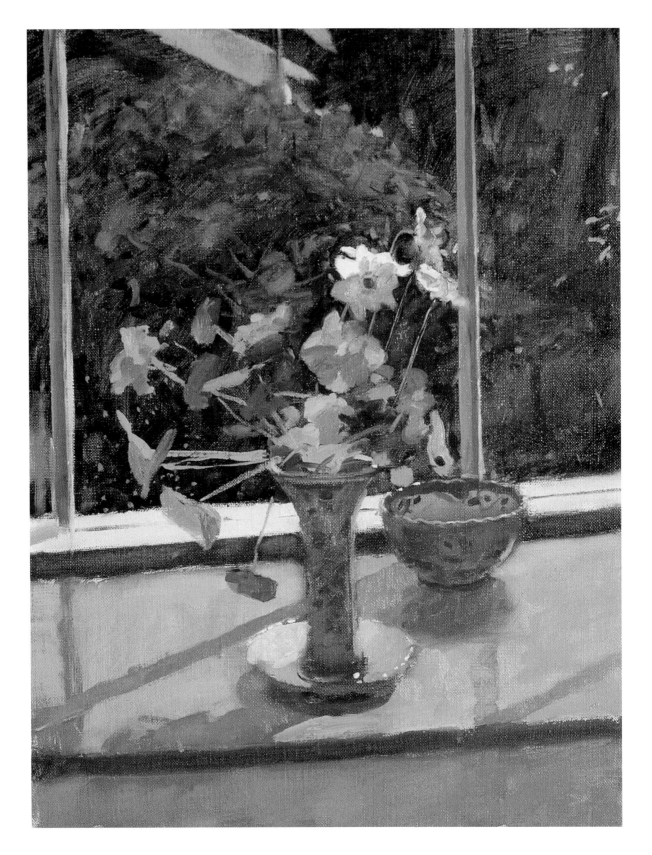

NASTURTIUMS (c1989)
Oil on canvas, 16 x 12in (40.5 x 30.5cm)

INDEX